Gilles Néret

Eugène Delacroix

1798 – 1863

The Prince of Romanticism

TASCHEN

KÖLN LONDON MADRID NEW YORK PARIS TOKYO

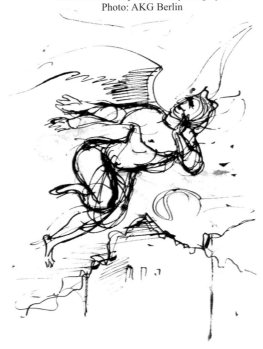

© 2000 Benedikt Taschen Verlag GmbH
Hohenzollernring 53, D–50672 Köln
www.taschen.com
Text and layout: Gilles Néret, Paris
Cover design: Catinka Keul, Angelika Taschen, Cologne
English translation: Chris Miller, Oxford

Printed in Germany
ISBN 3–8228–5988–5

Contents

6
The Prince of Romanticism

28
Gorged with Shakespeare and Dante…

50
The Charm of the Orient

66
Commissioned to Greatness

90
Life and Works

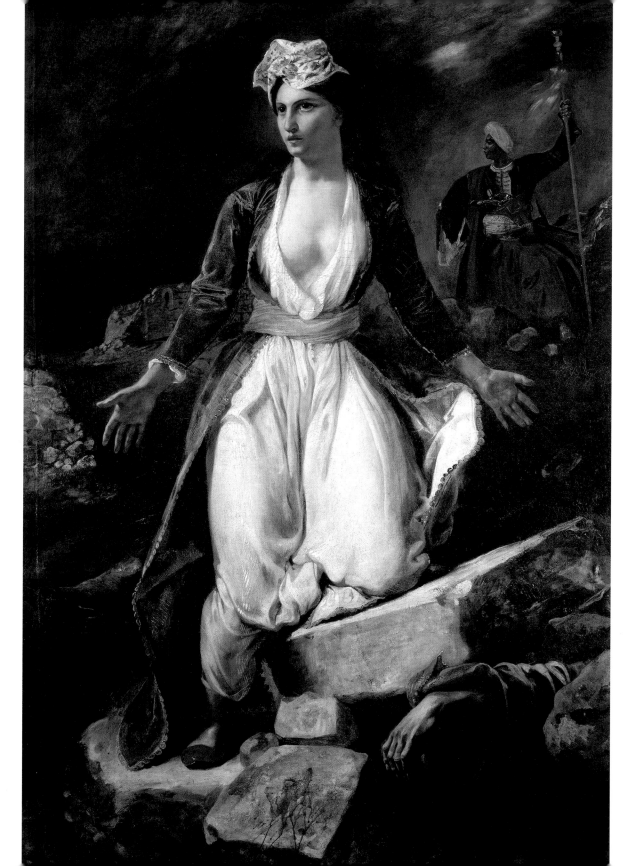

The Prince of Romanticism

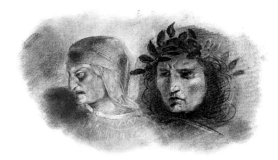

"The last of the great artists of the Renaissance and the first modern"; thus Baudelaire on Delacroix. For Baudelaire, Delacroix's position as one of the great figures of art history was assured not just by his daring and originality – qualities generally considered Romantic – but for the fact that they found expression within a tradition. Another great poet, Paul Valéry restated this paradox: "The veritable tradition in great things is not to repeat what others have done, but to rediscover the spirit that created these great things – and creates utterly different things in different times." Delacroix rediscovered the spirit of Michelangelo and Rubens, but the masterpieces that he created under their influence are of a very different kind. In his turn, Picasso made many studies of Delacroix's *Women of Algiers* (p. 53). In Kahnweiler's imaginary dialogue, Picasso tells Delacroix: "You took what you could from Rubens and made Delacroix of it. In the same way, I think of you and what I make is my own."

The last of the great Renaissance artists, Delacroix comes of a lineage whose founder is Michelangelo and whose prodigal son is Rubens. In his *Journal*, Delacroix more than once lays claim to this heritage: "Familiarity with the work of Michelangelo has exalted and elevated every subsequent generation of painters." Writing on Michelangelo, Delacroix speaks as the perpetuator of the tradition he describes: "The depiction of tender sentiments lies outside the bounds of Michelangelo's genius. In this work [*The Last Judgement* in the Sistine Chapel] above all, he indulged his taste for *terribilitas.* His imagination, oppressed by endless rereading of the Prophets, yielded only images of dread, and the solitude he cherished could only exacerbate his melancholy disposition."

In rendering homage to Michelangelo, Delacroix describes himself. The genius of Michelangelo is perhaps the closest kin to his own (in 1849–50, he imagined and painted Michelangelo's studio [p. 9]). Like Michelangelo, Delacroix inclines to *terribilitas*; his imagination too dwells on images of dread. From *The Massacre of Chios* (pp. 14–15) to *The Death of Sardanapalus* (pp. 20–23), the tragic visions of Delacroix portray horrors unequalled even in the Sistine Chapel. Charles Baudelaire, an unconditional admirer, puts it thus in his *Eugène Delacroix. Work and Life*: Everywhere we see "…desolation, massacres and fire; everything testifies to the eternal and incorrigible barbarity of mankind. Smoke rises from cities razed to the ground, the throats of victims are cut, women are raped, and children hurled beneath horses' hooves or pierced by the daggers of their raving mothers; this entire corpus is a hymn in praise of suffering inevitable and unrelieved".

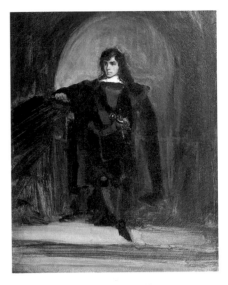

Self-Portrait as Ravenswood, c. 1821
Oil on canvas, 40.9 x 32.3 cm
Paris, Musée Eugène Delacroix

ABOVE:
Sketch for *The Barque of Dante: Heads of Dante and Virgil*
Charcoal, pencil and chalk, 20.4 x 30.7 cm
Paris, Musée du Louvre, Département des Arts graphiques

PAGE 6:
Greece on the Ruins of Missolonghi, 1826
Oil on canvas, 209 x 147 cm
Bordeaux, Musée des Beaux-Arts

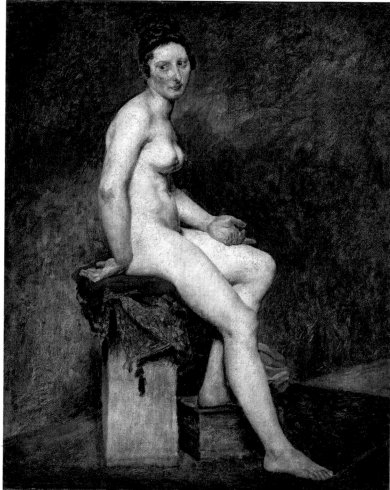

Mlle Rose, 1817–1820
Oil on canvas, 81 x 65 cm
Paris, Musée du Louvre

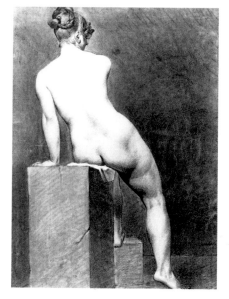

Richard Parkes Bonington
Study of Mlle Rose
Black and white chalk on paper, 59.5 x 44.5 cm
Paris, Private collection

The same nude drawn from life in the studio
of David's pupil Guérin.

PAGE 9:
Michelangelo in his Studio, 1849–50
Oil on canvas, 40 x 32 cm
Montpellier, Musée Fabre

Delacroix seems here to identify with
Michelangelo, whom he greatly admired, find-
ing in him a symbol of his own predicament as
a misunderstood artist. Michelangelo is seen
wearing a red scarf, an accoutrement for which
Delacroix was famous.

Though we trace Delacroix's artistic heritage directly back to Michelangelo
and Rubens, in the matter of colour there is a further influence, that of the Vene-
tian school. Delacroix is a master of colour, and his influence on Cézanne and
Matisse is clear. In his own words: "The work of a painter who is not a colourist
is illumination rather than painting. If one intends something other than cameos,
colour is, strictly speaking, one of the founding principles of painting, no less so
than chiaroscuro, proportion and perspective… Colour gives the appearance of
life."

As early as 1824, Stendhal had perceived in Delacroix "a pupil of Tin-
toretto". In his *Journal*, Delacroix noted: "In Giorgione, Titian and their pupils,
Venice possesses artists who perform miracles of colour without any derogation
from beauty." In Delacroix's words, "all the great problems of art were resolved
in the 16th century"; perfection "in drawing, grace and composition" had been
attained by Raphael, and in "colour and chiaroscuro" by Correggio, Titian, and
Paolo Veronese. Nonetheless, it was Rubens who, after Michelangelo, left the
most profound mark upon Delacroix's art. Delacroix was overwhelmed. The

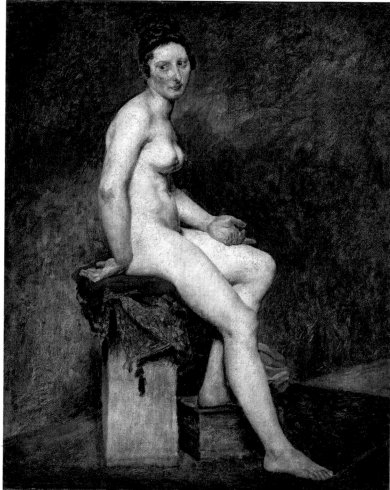

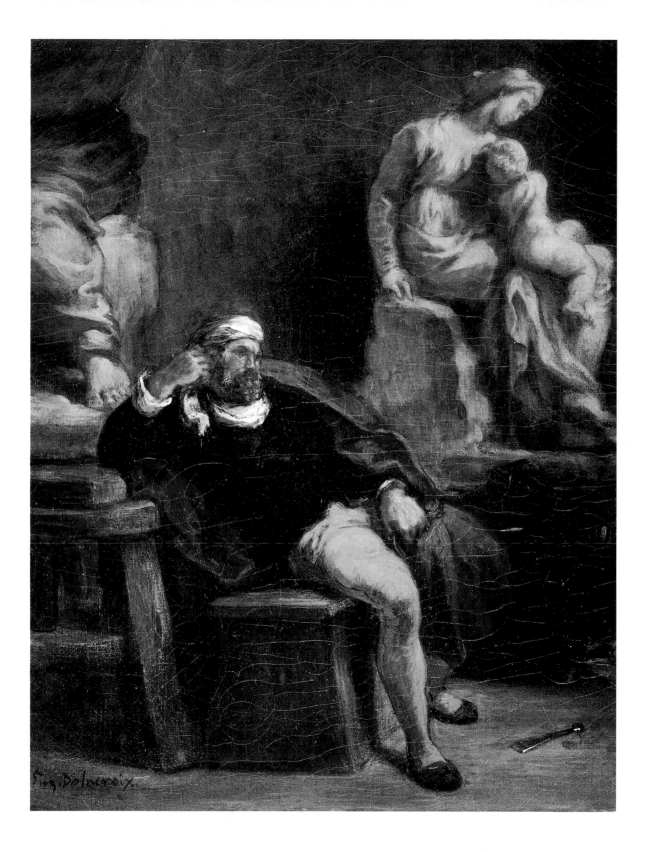

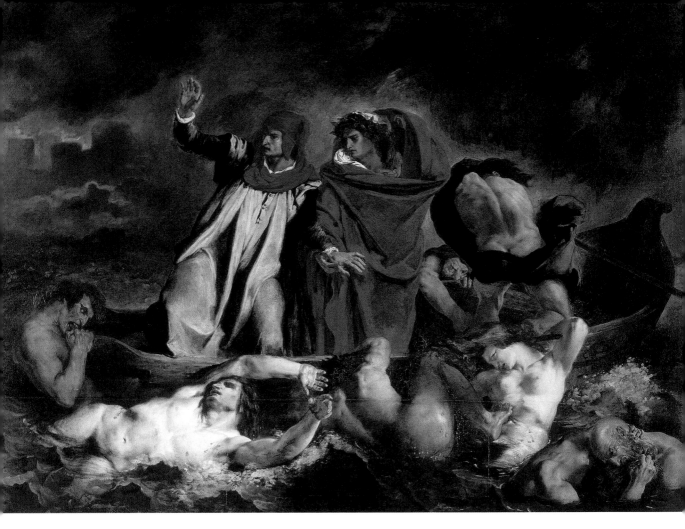

The Barque of Dante, 1822
Oil on canvas, 189 x 246 cm
Paris, Musée du Louvre

affinity between the swirling dynamic vitality of Rubens and Delacroix's art is clear: "Then comes Rubens, who had already forgotten the traditions of simplicity and grace. He created a new ideal through sheer force of genius. Strength, striking effects and expressiveness are pushed to their limits."

Maurice Sérullaz expands on this: "Delacroix perceived that, under the impetus of Rubens, a new epoch of art had opened up, an era of synthesis and equilibrium. On the one hand, there was the power, abundance, fiery dynamism, realism – and a certain penchant for Baroque eloquence and even effect. On the other, there was a nobility of conception and style, the paradigmatic harmony, sobriety and austerity of the Classical masters. Thus Delacroix discovered himself through Rubens. In Rubens, his own errors found their vindication. They had been severely criticised by his contemporaries, especially in his large decorative compositions; but, as in Rubens, they are the work of a genius at once rational and impulsive, inventive and objective, visionary and realist."

The superabundant life and decorative invention that typify the work of Rubens are present throughout Delacroix's career. To take just two examples, in *The Death of Sardanapalus* (1827–28), the women butchered upon the pyre derive from the Nereids in Rubens' *The Landing of Marie de' Medici at Marseilles*

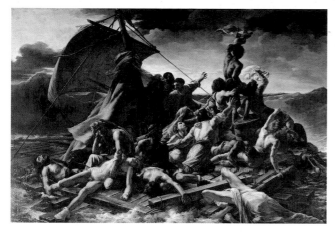

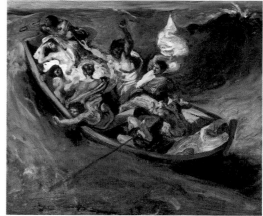

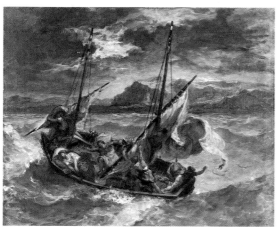

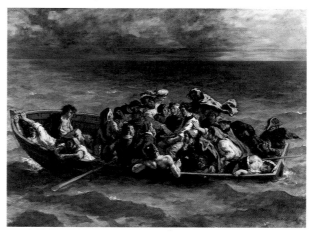

(1622–23, pp. 20–21), which Delacroix repeatedly copied; and the *Christ on the Cross* (1845) was inspired by a detail in another Rubens masterpiece, *Christ on the Cross (Le Coup de Lance)* (1620, pp. 46–47). For Delacroix admired in Rubens a quality that he himself possessed in abundance: the ability to unite allegory and history, and mould into a tumultuous whole figures mythological, historical, literary and real. He too could convey the turbulent movement of brightly coloured forms without disturbing the harmony of their arrangement and their overall composition in light and space.

"The last of the great artists of the Renaissance and the first modern…" Baudelaire's definitive description of Delacroix requires us to explain not only the influences that left their mark upon him, but how he was able to assimilate these; how he made use of them to construct his own originality. This, in its turn, became his own legacy, and his own influence has been very widespread. The lesson that he teaches is clear. It is not enough to imitate the great masters; one must, instead, draw on them for inspiration as one seeks to transcend their achievement.

In France, the master of the Classical school, David had long reigned supreme through sheer force of personality. It was therefore predictable that

ABOVE LEFT:
Théodore Géricault
The Raft of the Medusa, 1819
Oil on canvas, 187 x 491 cm
Paris, Musée du Louvre

ABOVE RIGHT:
Sketch for ***Christ on the Lake of Gennesaret***,
c. 1841
Oil on canvas, 45.7 x 54.2 cm
Kansas City (MO), The Nelson-Atkins
Museum of Art

BELOW LEFT:
Christ on the Lake of Gennesaret, 1854
Oil on canvas, 59.8 x 73.3 cm
Baltimore (MD), The Walters Art Gallery

BELOW RIGHT:
The Shipwreck of Don Juan, 1840
Oil on canvas, 135 x 196 cm
Paris, Musée du Louvre

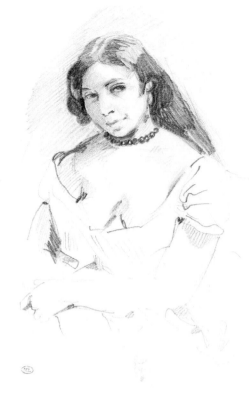

Sketch for *Aspasia*
Pencil on paper, 13.4 x 21 cm
Paris, Musée du Louvre, Département des
Arts graphiques

LEFT:
Aspasia, c. 1824
Oil on canvas, 81 x 65 cm
Montpellier, Musée Fabre

Delacroix should be accorded the role of official opposition to David, and perceived as the leading Romantic painter. Ingres had inherited David's mantle, and was acknowledged as Delacroix's *de officio* adversary. For Baudelaire, Romanticism was synonymous with modernity, and signified the revolt against a complacent past and the sacrosanct rules of the Academic style. Everywhere, in England and in Germany, these rules were being overthrown; new sources of inspiration were sought in an idealised past, an Orient still barely discovered, and the burning issues of the day. Delacroix presented every symptom of the Romantic malaise. Fiercely individualistic, he sought above all to render a state of mind, a condition of the human heart. Where the Classical style focused on discipline, careful composition, and precise draughtsmanship, Delacroix sought colouristic experiment and a sense of movement through which spontaneity, tension and drama could be expressed. He eschewed glossy surfaces and carefully graded colour transitions in favour of sharp contrasts and visible brush strokes. Only a great artist imbued with the lessons of the past can successfully defy those lessons, invent new rules and yet remain within the tradition. Perhaps it can only be done by one whose models have defied the lessons of *their* time. Delacroix was perfectly aware of this. When an admirer termed him "the Victor Hugo of painting", he coldly replied "No, sir, mine is the purest classicism." Delacroix is, without conflict, at once Romantic and Classical, and in his work the old and the modern serenely mingle: Rubens with Géricault, Shakespeare with Goethe.

PAGE 12:
Girl seated in a Cemetery, 1824
Oil on canvas, 65.5 x 54.3 cm
Paris, Musée du Louvre

Sketch for *The Massacre of Chios*
Watercolour over graphite on paper,
33.8 x 30 cm
Paris, Musée du Louvre, Département des
Arts graphiques

PAGE 15:
The Massacre of Chios (detail), 1824
Oil on canvas, 417 x 354 cm
Paris, Musée du Louvre

BELOW:
Théodore Géricault
The Demented Envier, 1822–23
Oil on canvas, 77 x 64.5 cm
Paris, Musée du Louvre

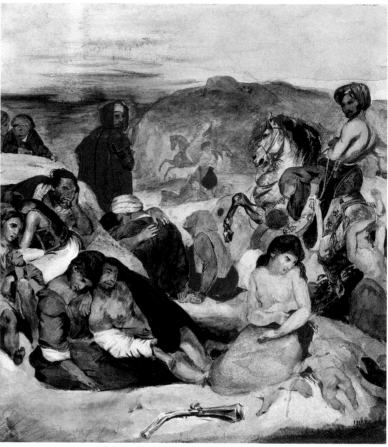

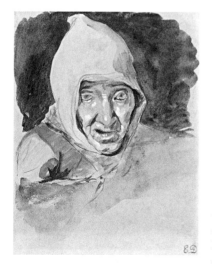

Study of an Old Woman for *The Massacre of Chios*
Watercolour on paper, 19.2 x 14.8 cm
Private collection

To that extent, the first of his paintings to achieve true notoriety, *Dante and Virgil in Hell* or *The Barque of Dante* (p. 10), exemplifies a duality that pervaded his entire career. True, the shared influence of Michelangelo and Rubens is manifest here too. But there is also a savour of the revolution so thunderously proclaimed by his friend and elder, Théodore Géricault, in his immortal painting, *The Raft of the Medusa* (1819, p. 11). This painting, it is often forgotten, caused a considerable stir on its first appearance; there were those who saw in it a political message, a provocation, an attack on the Royal French Navy made in the spirit of republicanism. It was not long before Delacroix too began to find inspiration in contemporary events, stimulating his imagination with the themes of modernity.

The Barque of Dante was submitted to the Salon in 1822, and makes clear acknowledgement of its debt to Gericault's *The Raft of the Medusa*. Indeed, the influence of that painting can be traced for many years afterwards in Delacroix's work, for example, in his *Christ on the Lake of Gennesaret* (1854) or *The Shipwreck of Don Juan* (1840, p. 11). The 'stage-setting' of *The Barque of Dante* looks forward to Baudelaire's pronouncement that Delacroix is an "essentially literary" painter. But Delacroix had something much more important to learn from the *Raft*. In expressing the predicament of the shipwrecked

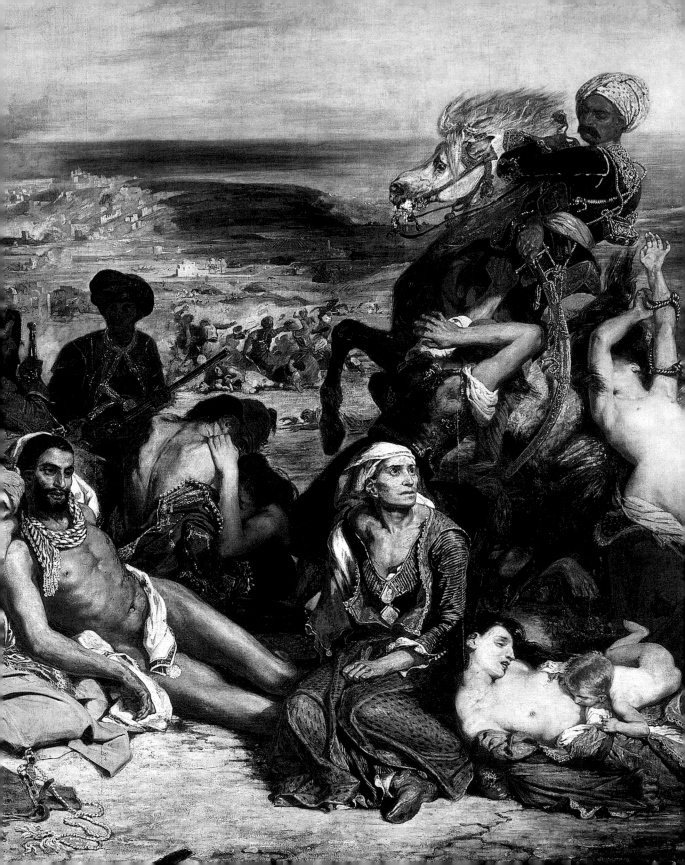

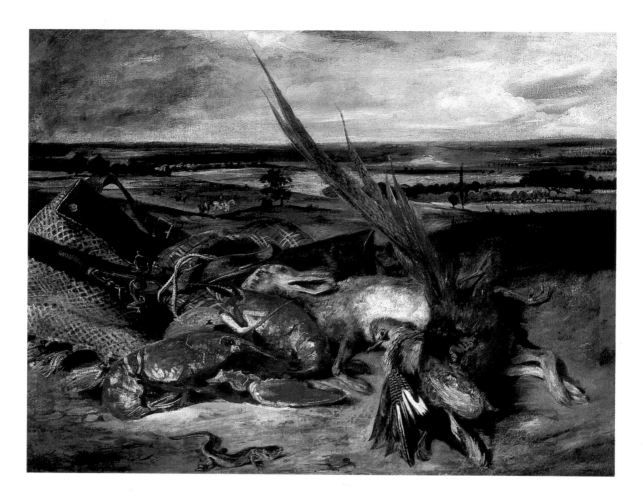

Still Life with Lobsters, 1826–27
Oil on canvas, 80.5 x 106.5 cm
Paris, Musée du Louvre

Original in conception, this virtuosic still life
is unique in Delacroix's œuvre, and shows
the influence of the English painting that
Delacroix had seen in London, in particular
Constable and Bonington. Delacroix tran-
scends the genre of still life by placing it in
a landscape.

everywhere in the world, Géricault had laid the foundations of an aesthetic
revolution. The *Raft of the Medusa* marks the first appearance in painting of
'the ugly' and thereby proclaims its scrupulous respect for the truth, however
repulsive the truth might be. This concern for truth is integral to the Romantic
temperament.

Horrified by the massacres perpetrated in Greece by the Sublime Porte,
Delacroix denounced this crime against humanity – this genocide. His denuncia-
tion took immediate form in *The Massacre of Chios* (1824, p. 15); his gesture
parallels that of his fervent admirer, Picasso, in his representation of the mas-
sacre at Guernica. Delacroix depicted a landscape racked with fire, stretching
desolately behind a group of prisoners awaiting execution. The painter Antoine-
Jean Gros, an admirer of Delacroix who had hailed *The Barque of Dante* as
"Rubens purified" – to Delacroix's great satisfaction – this time spoke of "the
massacre of painting". The *Massacre* is all but a manifesto in its liberated ex-
pression of light and atmosphere through colour; after it, 19th century painting
could never be the same again.

Greece made a second appearance in Delacroix's work in 1827. Its symbol
was a young woman in national costume standing on a block of stone from
which there emerges the hand of a dead insurgent. *Greece on the Ruins of*

Missolonghi (p. 6) elicited an immediate response from Baudelaire: "The audacity of Michelangelo and the fecundity of Rubens." Others disagreed; they would have preferred Delacroix to be less "exuberant". The painter François Gérard – described by Baudelaire as "more an intellectual than a painter" – saluted the advent of a new painter, but added that he was a madman "running along the rooftops". And the Director of the Beaux-Arts, if we are to believe Baudelaire, told Delacroix that it was mortifying to see a man so rich in imagination and of so fine a talent refusing to "water down his wine a little". The foreign policy of France was the business of its ministers and not of its artists.

The following year, Delacroix compounded his sins. His *Death of Sardanapalus*, inspired by the work of another Romantic, the poet Byron, unleashed upon an offended audience an avalanche of colour and movement. The savour of the work was too strong for jury and critics, and they hastened to condemn it. The headlong Rubensesque draughtsmanship was deemed careless; errors of perspective were said to account for the uncertainties of the space portrayed and the confusion of the foreground. Delacroix observed: "…very asinine members of the jury; they will convince me at length that I have indeed failed". In

A Mortally Wounded Brigand Quenches his Thirst, c. 1825
Oil on canvas, 32.5 x 40.7 cm
Basle, Öffentliche Kunstsammlung Basel, Kunstmuseum

Delacroix's experience of English artists is again reflected here, alongside the influence of Venetian painting and the works of Rubens. A critic remarked: "The colour of this piece is as beautiful as some landscape imagined by Byron as the setting for the bloodstained body of one of the tyrants of Missolonghi."

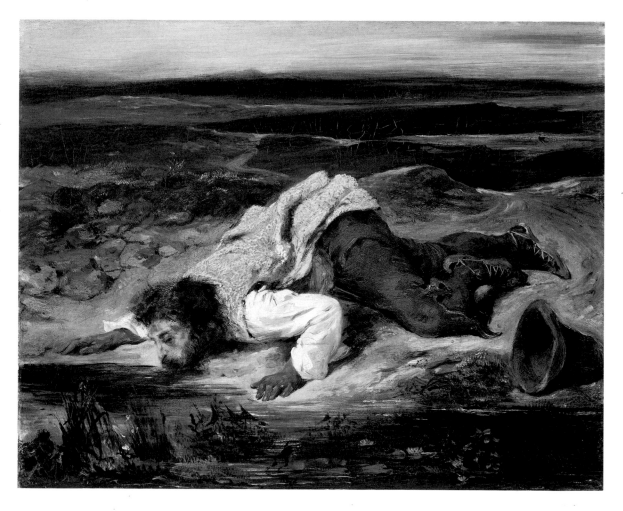

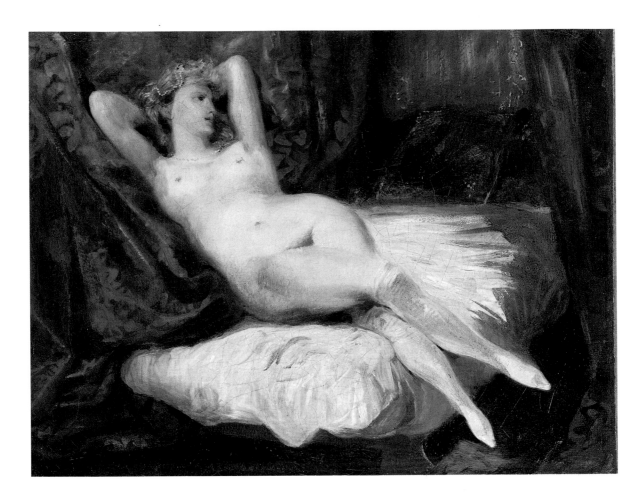

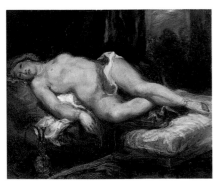

Odalisque Reclining on a Divan,
c. 1827–28
Oil on canvas, 37.8 x 46.4 cm
Cambridge, Fitzwilliam Museum, University
of Cambridge

The Death of Sardanapalus, the three sacrosanct unities of the Academic style were indeed overthrown. But, transcending the laws of perspective, the canvas demonstrates absolute stylistic coherence in its free play with sinuous volumes, while every component of the painting – clothes, flesh and objects – testifies to Delacroix's virtuosity. In *The Massacre of Chios*, Delacroix had already plunged deep into the depiction of horror. But in *The Death of Sardanapalus*, he painted an apotheosis of cruelty, and this was not to be forgiven. The composition, all reds and golds, portrays the holocaust of the legendary Assyrian king, destroying his possessions before committing suicide. The insurgents are attacking his castle; all is lost; "stretched out on a sumptuous bed at the summit of an immense pyre, Sardanapalus orders eunuchs and palace officers to cut the throats of his women, his pages, and even his favourite dogs and horses; none of the objects that have served his pleasure are to survive him". His women are placed on a level with his horses and dogs.

The diagonal rhythms, the fluidity of line, the brilliance of the colours and its profound sensuality make *The Death of Sardanapalus* a masterpiece of 19th-century art. But for the hypocritical public that acclaimed executions with cries of 'To the scaffold!' it was merely scandalous. The woman writhing at the foot of the royal bed (detail, p. 23) as a dagger is raised to her throat wears an expres-

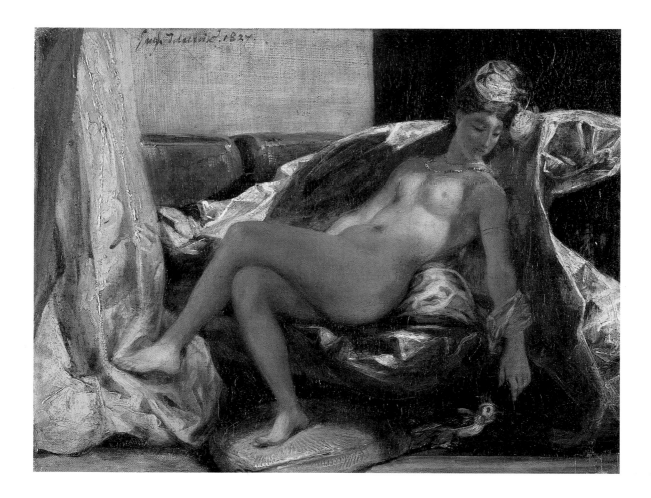

sion of suffering too voluptuous for contemporary taste. The critics sniggered, and for a while government commissions were not forthcoming.

Ingres, the arch-classicist, had elongated the female form, emphasising its sinuous curves; Delacroix's slave-girls are wild-haired and arch their backs. The latter are women of flesh and blood, conscious of their carnality and playing upon it as if upon Ingres' famous violin. A prey to terror, they know that death is imminent; before their eyes, their butchers, Sardanapalus' henchmen, are at work, and they vibrate as they might have done beneath the caresses of the king. This is a holocaust of orgasm and death. Through this mass of bodies driven to spasms of anguish and ecstasy, Delacroix has transmitted a frenzied vitality. The woman writhe like the flames that surround the princely catafalque – bed – of Sardanapalus. The spectacle is one to gladden the heart of de Sade: here is a man of sufficient power to spread terror and death in his wake, whose ultimate pleasure is the total destruction of this mountain of flesh, cries, corpses breathing their last, proud beasts and untold splendours, at whose summit he lies enthroned. Here is the ultimate self-destruction, a prince whose suicide takes the forms required by his rank and beliefs, in the murderous pomp and ceremony of a massacre. Blood mingles with precious stones in a tumultuous cascade. The horses rear, the women recoil in a vehement symphony of rump and crupper.

Woman with a Parrot, 1827
Oil on canvas, 24.5 x 32.5 cm
Lyons, Musée des Beaux-Arts

PAGE 18, ABOVE:
Female Nude Reclining on a Divan,
c. 1825–26
Oil on canvas, 25.9 x 33.2 cm
Paris, Musée du Louvre

There is a manifest sensuality to these dreaming women with their bodies offered up to the spectator's gaze, and we know from the *Journal* that Delacroix's relations with his models often went beyond the pictorial; but there are also traces of the influence of Bonington in their presentation, and perhaps of Delacroix's desire to emulate Ingres' nudes.

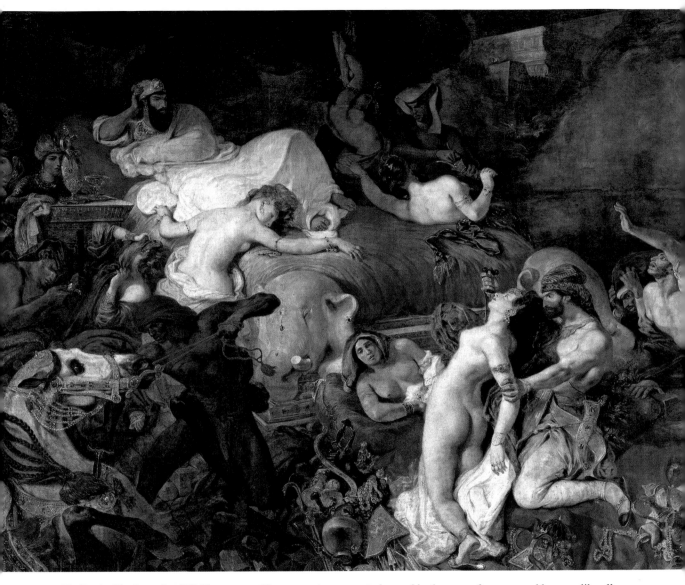

The Death of Sardanapalus, 1827–28
Oil on canvas, 392 x 496 cm
Paris, Musée du Louvre

PAGE 21, LEFT:
Sketch of a Female Nude, killed from behind
Pastel, red and white chalk on paper,
40 x 27 cm
Paris, Musée du Louvre, Département des
Arts graphiques

The orgasmic ecstasy to be read in the eyes of women and horses alike allows no distinction between pleasure and panic.

Clearly, the choice of subject was not an innocent one. By no less conscious a decision, when the slave-girl at last achieved liberation in his work, it was as the flag-bearer of *Liberty Leading the People* (1830, pp. 24–27), a sort of epic narrative of the woman who quits her hearth to espouse a great cause. Here too there is a carpet of bodies beneath her feet as she leads the ravening crowd. In a further transformation, her naked breasts have come to embody the social virtues of Republicanism, a point officially acknowledged by the generous diffusion of the image in the form of French stamps. It is also the first modern political composition. It marks the moment at which Romanticism abandoned its classical sources of inspiration to take up an emphatic role in contemporary life. Delacroix wrote to his brother, the general: "I've set about a modern subject, a

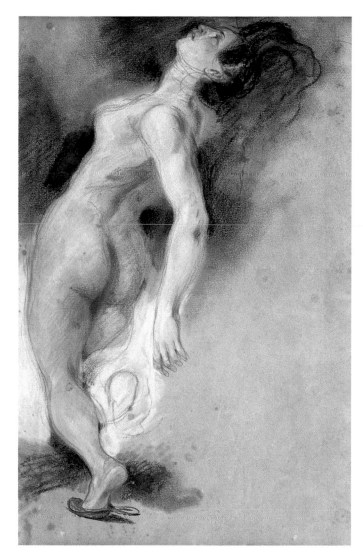

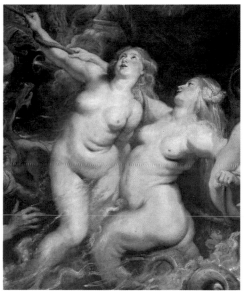

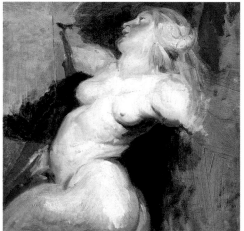

barricade… Since I have not fought and conquered for the fatherland, I can at least paint on its behalf." Delacroix nonetheless enrolled as a *garde national*, and in this role he portrayed himself, wearing a top hat, to the left of Liberty (p. 24). The young drummer brandishing his pistols to the right of Liberty (p. 27) was, perhaps, the inspiration for the character Gavroche, in Victor Hugo's *Les Misérables,* written thirty years later. Delacroix's influences – Goya, Gros, and, above all, Géricault – are clearly apparent. King Louis-Philippe bought the work for 3,000 francs, but was not so foolish as to exhibit it.

Delacroix's bare-breasted political icon derives in part from the iconographic nudity of saints, and his Liberty belongs to the tradition of sado-masochistic madonnas painted for the church. In *The Death of Sardanapalus,* he drew on another tradition, in which the mystico-erotic deliriums of the Under-world are depicted alongside other bacchanalia, their satanic imagery forming

ABOVE:
Nereid (copy after Rubens), c. 1822
Oil on canvas, 46.5 x 38 cm
Basle, Öffentliche Kunstsammlung Basel, Kunstmuseum

ABOVE RIGHT:
Peter Paul Rubens
Nereids, detail from *The Landing of Marie de' Medici at Marseilles*, 1622–23
Oil on canvas, 394 x 295 cm
Paris, Musée du Louvre

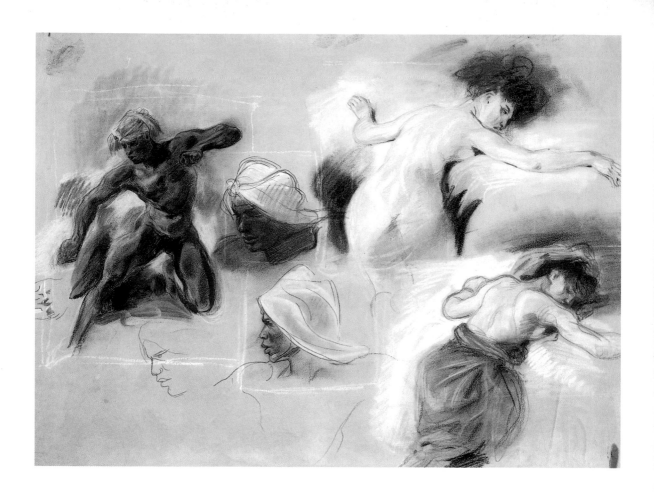

Sketch for *The Death of Sardanapalus*
Pastel over graphite, red and white chalk and
black crayon on unbleached paper, 44 x 58 cm
Paris, Musée du Louvre, Département des
Arts graphiques

PAGE 23:
The Death of Sardanapalus (detail)

the underpinning required by a theologised universe. The masses have always
appreciated human sacrifices to gods, kings or principles. If Romanticism con-
forms to Racine's definition of tragedy, in requiring for its subject "a princess
undergoing misfortune", Delacroix is undoubtedly the prince of Romanticism.

Baudelaire was aware of the central role played by Delacroix in the devel-
opment of 19th-century art: "What will posterity have to say about M. Delacroix?
Accustomed as it is to righting injustices, how will it judge him?" He was able
to name those who had influenced Delacroix, even as he declared him "unpre-
cedented". But even he could hardly have guessed how the many artists, later in
the century, would name Delacroix as their inspiration. They include Edouard
Manet, Paul Signac, Georges Seurat, Henri Matisse and Pablo Picasso – in short,
the aristocracy of modern art. Their debt to him was real, and they acknow-
ledged it publicly.

Indeed, Signac wrote a critical treatise – *From Eugène Delacroix to Neo-
Impressionism* – in which he specified the nature of this debt. What interested
subsequent generations of painters was not Delacroix's romanticism, but his
individuality and his technique. Manet twice copied Delacroix's first master-
piece, *The Barque of Dante* (c. 1855, Musée des Beaux-Arts, Lyon, and c. 1859,
Metropolitan Museum, New York). Antonin Proust, in his *Edouard Manet,*

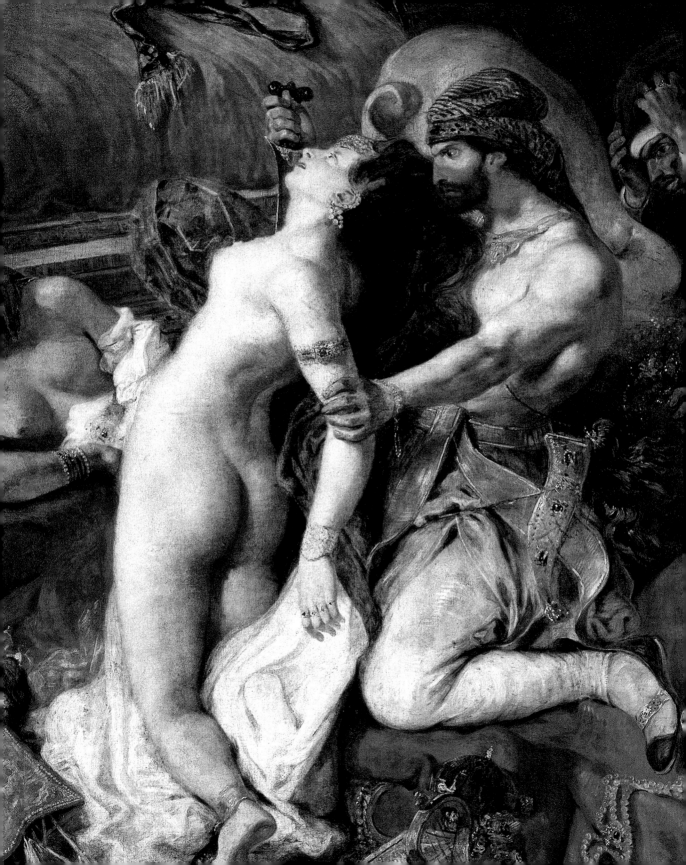

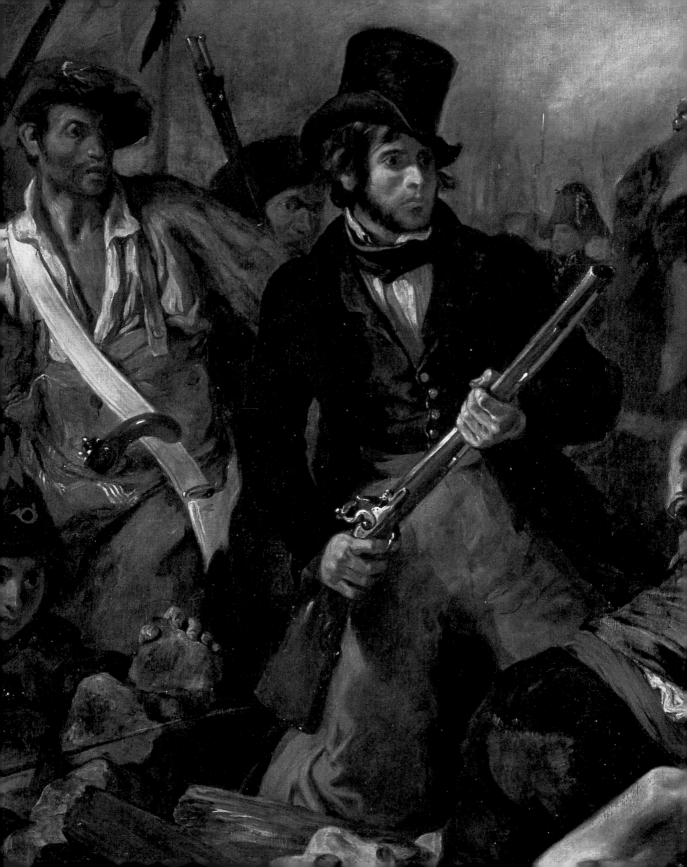

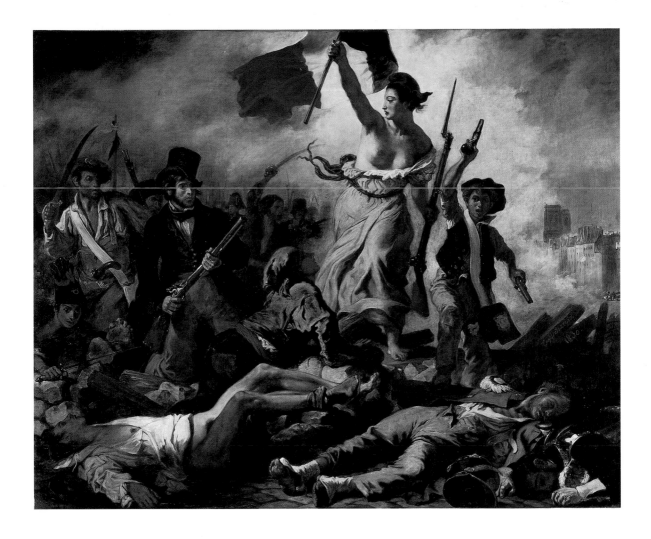

Souvenirs, recounts a visit by Manet – who was, in his turn, labelled "the first modern artist" – to the aged Delacroix in his Notre-Dame-de-Lorette studio. "Delacroix received us… very graciously, questioned us about our preferences and stated his own. We were to examine Rubens, be inspired by Rubens, copy Rubens; Rubens reigned supreme… When the door had closed behind us, Manet remarked: 'It's not Delacroix who is cold, it's his doctrine, which is glacial. All the same, let's copy the *Barque*. It's a marvel'".

What struck Manet was, nevertheless, the influence of Rubens, which is visible despite the impact of Géricault and his powerfully contrasted chiaroscuro. Certain details made a deep impression on Manet, in particular the drops of water suspended on the bodies of the damned who grasp desperately at the gunwales of the boat. The drops derive directly from those rolling from the skin of the Nereids at the base of Rubens' painting *The Landing of Marie de' Medici at Marseilles*, a work that also influenced *The Death of Sardanapalus* (detail p. 21). In *The Barque*, they are realised by little strokes of juxtaposed pure colours. They thus illustrated, long before the Impressionists, the theories

Liberty Leading the People (28 July 1850),
1830
Oil on canvas, 260 x 325 cm
Paris, Musée du Louvre

PAGE 24:
Liberty Leading the People (detail)
Self-portrait of Delacroix as a revolutionary

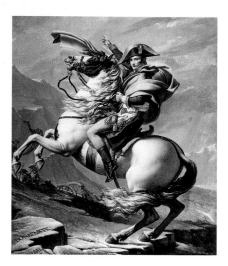

Jacques-Louis David
Napoleon Crossing the Alps, 1801
Oil on canvas, 271 x 232 cm
Rueil-Malmaison, Musée National du Château
de la Malmaison

The rhetoric of heroism is constant between
the Romantic Delacroix and the Neo-classical
David, but the stylistic differences are mani-
fest.

PAGE 27:
Liberty Leading the People (detail)

Contemporary criticism focused on the eroti-
cism of the bare breasts, the dirty skin and the
suggestion of hair at the armpits. These were
taken to indicate that the goddess of liberty
was a woman of the people, a fishwife, a
Venus of the streets and not a countess from
the Faubourg Saint-Germain.
Thirty years later, Victor Hugo immortalised
the urchin as Gavroche, in *Les Misérables*.

of the physician Chevreul, set out in his work *On the Law of Simultaneous Con-
trast Between Colours*; this was the breviary of the Impressionists and the Bible
of the Neo-Impressionists. Morever, in *The Barque*, colour is conceived not only
in terms of chiaroscuro, as in Géricault, but for its expressive value. The con-
trasted green-blues and reds determine the dramatic tonality of the entire com-
position, illuminated, as so often in Delacroix, by white highlights. When we
consider that Manet was still a student in the academic studio of Thomas Cou-
ture when he saw the painting, we can imagine the impact it had on him and the
lessons that he was able to learn from it.

For the Impressionists, Delacroix was both an inspiration and a forerunner.
For Cézanne, who copied the *Women of Algiers in their Apartment* (p. 53) and
The Barque, Delacroix was an idol; the sombre tonality of *The Barque* left
its mark on Cézanne's entire corpus. We know twenty-seven variations on
Delacroix in Cézanne's corpus, and in his Aix studio hung two oil-paintings, one
watercolour, two lithographs and six reproductions by Delacroix that he owned.
The flowers depicted in the watercolour inspired an oil-painting (p. 84), in
which the rhythmic and chromatic traits of the original were pushed toward ab-
straction. His praise of *Women of Algiers in their Apartment* attains to poetry:
"We all have our place in this Delacroix. When I talk about the joy of colour for
colour's sake, that's what I mean… These pale roses, these shaggy steeds, this
Turkish slipper, all this limpidity, I don't know, they go in at the eyes like a glass
of wine going down the throat, and immediately, you're drunk on it. You don't
know how, but you feel lighter… Things start to spin round one. It's the first
time volumes have been painted since the masters. And in Delacroix, there's
something else, a fever, which isn't there in the masters. …Yes, whatever people
say or do, he's part of the great line. You can talk of him, without blushing, even
after Tintoretto and Rubens. …Delacroix is Romanticism, perhaps. He gorged
himself with Shakespeare and Dante, it was overindulgence, he leafed through
Faust too often. But he still has the most beautiful palette in France, and no one
else in this country has managed the calm and the moving at the same time, the
vibration of colour. We all paint in his shadow."

From his asylum at Saint-Rémy, in 1899, Van Gogh asked to be sent engrav-
ings of Delacroix paintings such as *The Good Samaritan* and the *Pietà* (p. 48);
the humane intensity of their themes chimed with his own most profound pre-
occupations. Standing before these black and white images, inverted by litho-
graphic reproduction, Van Gogh improvised dialogues, invented his own
colours, and sought to remember the originals and their exact colours, which
had so deeply impressed him "…even when they're not exactly right – that
part's my own interpretation".

Van Gogh's was only the first of a series of such homages. Delacroix's œu-
vre is echoed in many different painters. One artist after another followed his
route toward the Orient: Renoir, who made his own version of the *Women of Al-
giers* (1872, The National Museum of Western Art, Tokyo), Matisse, who voy-
aged through Morocco in search of odalisques, Klee, who invoked Delacroix's
name on his journey through Tunisia, and Picasso, who espoused the *Women of
Algiers* and remained faithful to it for the rest of his life. The variety of re-
sponses in these reminiscences from such a range of artists testifies to the fecund-
ity of Delacroix's work. For some, Delacroix's compositional genius was the
principal inspiration; for others his treatment of paint constituted a revelation.

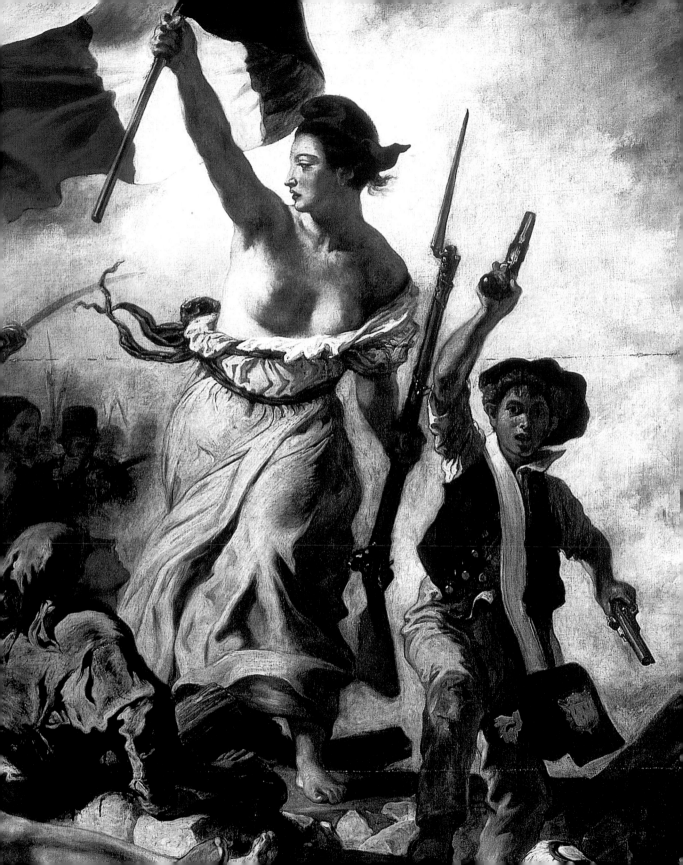

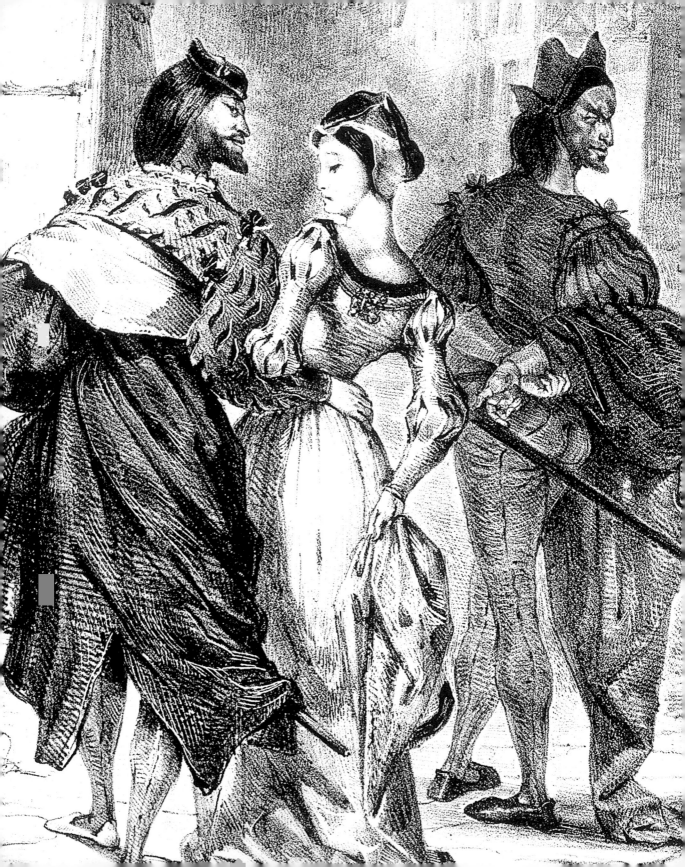

Gorged with Shakespeare and Dante…

"Delacroix is Romanticism, perhaps. He gorged himself with Shakespeare and Dante, it was overindulgence, he leafed through *Faust* too often. But he still has the most beautiful palette in France…" Cézanne's encomium is at one with Baudelaire's observation that Delacroix is an "essentially literary" painter.

Of all the artists of his time, as *The Barque of Dante* and *The Shipwreck of Don Juan* illustrate, Delacroix is undoubtedly the most literary in inspiration. From the moment he began to paint, first under the undemanding supervision of his teacher, the academic Guérin, then at Géricault's side, the young Delacroix never ceased to build on the solid literary education that he had received at the Lycée Impérial (now the Lycée Louis-le-Grand). But his literary tastes, as he notes in his *Journal*, are entirely his own: "…unlike most people, whose reading has helped them progress in life's wars, I sometimes read only to confirm the progress that I have made in my heart of hearts. You see, since I left school I have read nothing, or rather, I haven't read. So I am entranced by the wonderful things that I find in books; I am not at all blasé."

Baudelaire adds to this: "Not only has his painting ranged with invariable success through the field of great literature, not only has it frequented and transposed Ariosto, Dante, Shakespeare, Byron and Walter Scott, but it has revealed ideas subtler and more profound than those of the majority of modern painters."

Indeed, Delacroix himself wrote a major literary work, his *Journal*, which merits comparison with the masterpieces of the genre. Even today, they are an inspiration for the painter setting out on his or her career. Maxime Du Camp was famous for his caustic judgements, but even he was obliged to acknowledge in his *Souvenirs littéraires* that the "leader of the revolutionary school of painting", that tiger of sanguinary habit, was also a beast of impeccable style. And he adds: "…it is as if he took upon himself to reject this imputation by the orthodoxy of his attitudes and by his courteous demeanour". To such an extent that Baron Gérard once remarked: "When I meet you like this, Delacroix, if I were unacquainted with your painting, I should ascribe to you the works of M. Ingres."

Alexandre Dumas, who frequented the same salons, memorialised Delacroix in a portrait that emphasises his amiability and tact. The social esteem in which he was held may have helped him endure his low repute as an artist. Thus Dumas: "Subtle, a controversialist and prompt in his repartee, he loved to joust, and when he did, his wit came into its own, glittering with insights brilliant, novel, and precise… When he had delighted his audience with lively, picturesque conversation, one might, as he left the house, hear the mistress of the household exclaim: 'What a charming man M. Delacroix is, and what a pity he is so set on painting!'"

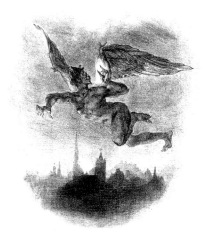

Mephistopheles Aloft, 1828
Lithograph, 27 x 23 cm
Paris, Musée Eugène Delacroix

ABOVE:
Head of Mephistopheles, 1824–1828
Extract from a sketch book
Brush and wash
Paris, Musée du Louvre, Département des Arts graphiques

PAGE 28:
Faust Trying to Seduce Margarete, 1828
Lithograph (detail), 26.2 x 20.8 cm
Paris, Musée Eugène Delacroix

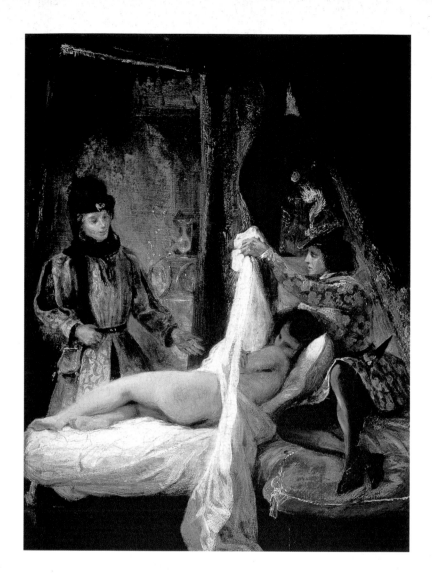

Louis d'Orléans Showing his Mistress,
1825–26
Oil on canvas, 35.2 x 26.8 cm
Madrid, Fundación colección Thyssen-
Bornemisza

It was in England that Delacroix's relation to literature received a deter-
mining impetus. The world of Goethe was revealed to him by a performance of
Faust given by an English company. For Delacroix, the key figure is not Faust,
but, of course, Mephistopheles, demonic and Romantic in equal measure. By
chance, at the same time Delacroix received a message from Charles Motte, a
publisher of lithographs similarly attracted to Goethe's play: "…If you had a
few moments to sacrifice to me, we might perhaps arrange a diabolical affair
with Faust. I have a few ideas to put to you for the exploitation of that sorcerer."

Two years passed before the project took shape, as Delacroix was busy fin-
ishing *The Death of Sardanapalus* for the 1827 Salon. But eventually seventeen
plates resulted. Henri Beraldi, in his *Graveurs du XIXᵉ siècle*, wrote in 1886:
"Delacroix's *Faust* now seems to us wild and disorderly in its romanticism. Its
interest lies precisely in this violence. It was the profession of faith of the young
school, and has been compared, in its importance, with the *Préface de Cromwell*

[the Romantic manifesto against "the despotism of systems, codes and rules" with which Victor Hugo prefaced his verse drama of that name, published in 1827]. The times then required not reason, but 'truculence'. Delacroix was indeed 'truculent', but he effected a revolution in Art."

Predictably, the critics censored what they saw as technical eccentricity – Delacroix's almost completely inked plates and slashing use of the scraper. In their view, his forms and figures lacked purity and his poses were excessively contorted. But Goethe himself was delighted. Eckermann recorded his judgement: "'It must be admitted,' said Goethe, 'that I myself scarcely imagined the scene so perfectly! M. Delacroix is a great artist of exceptional talent, who has found in *Faust* precisely the subject that suits him. The French criticise his impulsive style; but here it is just what is required. He will – at least, I hope he will – illustrate the whole of *Faust,* and I look forward to the pleasure of seeing it, particularly the witches' kitchen and the Brocken scenes. Clearly Delacroix has a profound knowledge of life; in such matters a city like Paris is the perfect teacher.'"

From this point on, Delacroix abandoned subjects of burning contemporary interest. In place of powerful narrative scenes like *The Massacre of Chios*, *Greece on the Ruins of Missolonghi*, and *Liberty Leading the People*, Delacroix now chose subjects inspired by literature or history. Not that his opinions had changed, as the analogies between *The Massacre of Chios* (pp. 14–15) and *The Entry of the Crusaders into Constantinople* (pp. 36–37) demonstrate. In both, there is a meditation on the misfortunes of war, in both the conquerors on their trembling steeds tower over prostrate women.

One experiment was not repeated. *Louis d'Orléans Showing his Mistress* (p. 30) illustrates an episode from Brantôme's *Vies des dames galantes*; the Duke lifts a veil from his nude mistress for the edification of his chamberlain. However, he takes care to conceal her face, for she is, in fact, the chamberlain's wife. It seems probable that Delacroix, always short of money, chose this subject in hopes of a quick sale. The style and thematic presentation owe much to Delacroix's English friend Bonington, who was something of a specialist in small-format paintings. Bonington, too, was a Romantic, but tended to perceive in history only amusing, gallant and picturesque episodes; he showed no interest in historical analogy or exemplary heroic virtue. (His version of *Mlle Rose* [p. 8] dates from the period when he and Delacroix attended the same Paris studio). The reductive motive may seem surprising in the painter of *The Massacre of Chios,* but Delacroix could not, given the prevailing tastes, survive on genius alone. Moreover, the rich colours and textures and the extraordinary virtuosity of the brushwork are pure Delacroix. A series of superlative nudes followed from this precedent.

One such is the *Recumbent Odalisque*, also known as *Woman with a Parrot* (p. 19), which Delacroix painted on his return from England. Representing one of Delacroix's favourite models, Laure, it forms one of a series of nudes, which includes the *Female Nude Reclining on a Divan* in the Louvre and the *Odalisque* of the Fitzwilliam Museum, Cambridge (p. 18). In their tonal refinement – red lake and carmine predominate – they emphasise the connections between Delacroix and Bonington. The women thus portrayed might, says Baudelaire, be at one and the same time Ophelia, Desdemona or Medea: "Their pallor is like a revelation of inner turmoil. Breathing the charms of crime or the odour of sanc-

PAGE 32:
The Murder of the Bishop of Liège (detail), 1829
Oil on canvas, 91 x 116 cm
Paris, Musée du Louvre

The Battle of Taillebourg (draft), 1834–35
Oil on canvas, 53 x 66.5 cm
Paris, Musée du Louvre

tity, languid or violent of gesture, these women are sick in heart or mind, and their eyes are livid with fever… M. Delacroix seems to me the artist most suited by his talents to express modern woman in her heroic manifestation, whether this be infernal or divine. The physical beauty of these women is itself modern: an air of *rêverie*, large breasts on a rather narrow chest, with a broad pelvis and charming arms and legs." Courbet, Manet and Matisse are among the artists who later took up Delacroix's theme of the *Woman with a Parrot*.

"Everything is subject matter," Delacroix once said, not in self-excuse, but in affirmation of the fact that it was the treatment that counted. This was indeed a modern and a revolutionary idea; that the artist's technique and sense of composition were at the service of the initial stimulus. He wanted the picture to be a work in itself, independent of the subject and any picturesque or anecdotal element that it might comprise; the "poetry of composition" that he was among the first to practise ensured that this was so. This aspect of Delacroix is summed up succinctly by Maurice Sérullaz: "He is a catalyst, and his forms, colours, rhythms and even ideas are such as can inspire any generation of painters to come."

PAGE 35:
The Battle of Taillebourg (draft; detail:
the white horse ridden by Louis IX)

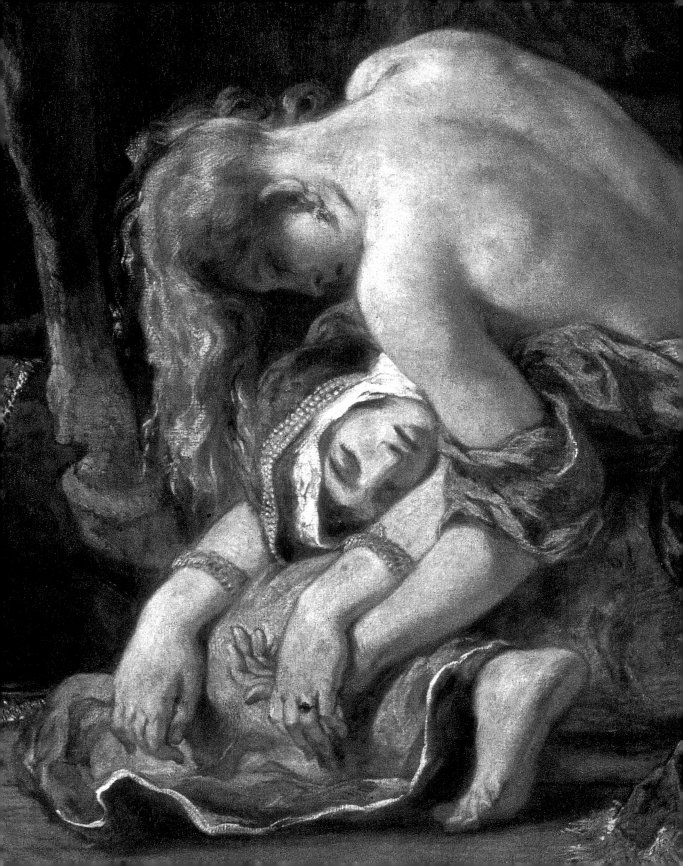

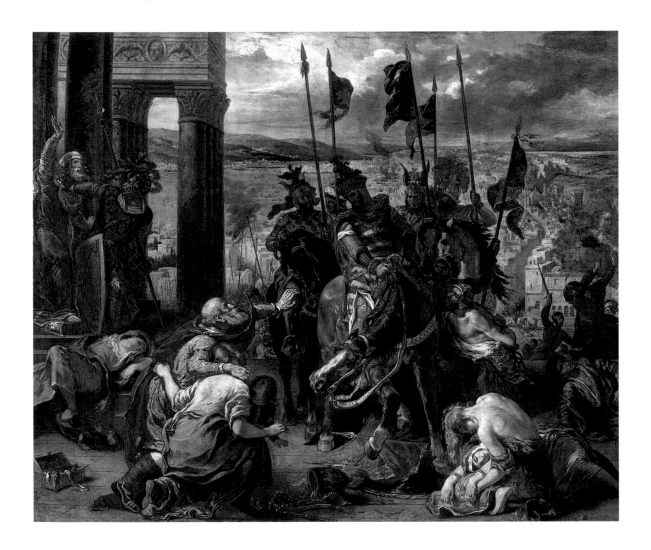

The Paris of the Romantic era was under the spell of Scott and Byron. The historical novel was all the rage, and the French Romantics, notably Hugo and Dumas *père,* were subject to this combined influence. As early as 1821, when he was twenty-three years old, Delacroix painted himself as *Ravenswood* (p. 7), Lucy's lover in Sir Walter Scott's novel *The Bride of Lammermoor* (1819).

Scott's ability to enliven history by recounting its effects upon the lives of the humble overwhelmed Delacroix, who wrote to Pierret in 1822: "Never before have I felt such vivid emotions in reading good things; a good page makes a delicious impression on me, which lasts for several days. I hate unrealistic writers who have only style and thought without a true and sensitive source."

Delacroix's treatment of subjects from fashionable works frequently raised critical hackles, and he was assailed in the name of good taste, the Beautiful, and the Ideal. A notable victim of such disparagement was the scene drawn from Scott's *Ivanhoe.* The version of the *The Abduction of Rebecca* (p. 45) now in the Louvre was exhibited at the 1859 Salon, and shows Rebecca carried off by Sir Brian de Bois-Guilbert, while in the background flames engulf Torquilstone

The Entry of the Crusaders into Constantinople, 1840
Oil on canvas, 410 x 498 cm
Paris, Musée du Louvre

PAGE 36:
The Entry of the Crusaders into Constantinople (detail of the women surrendered to the invaders)

PAGE 38, ABOVE LEFT:
George Sand (unfinished), 1838
Oil on canvas, 79 x 57 cm
Ordrupgaard, Ordrupgaardsamlingen

PAGE 38, ABOVE RIGHT:
Frédéric Chopin (unfinished), 1838
Oil on canvas, 45.7 x 37.5 cm
Paris, Musée du Louvre

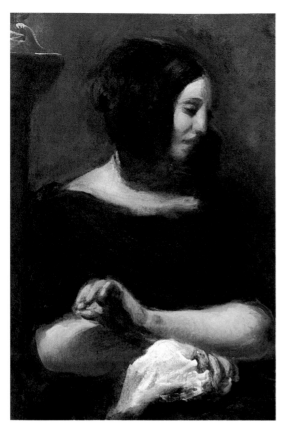

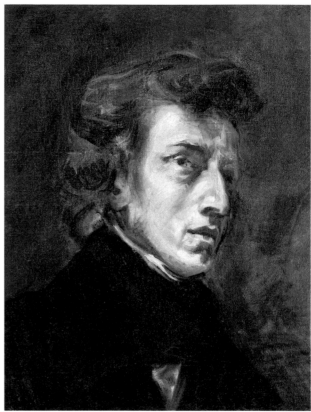

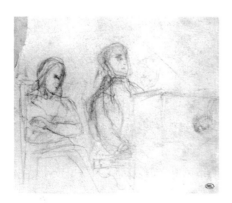

Castle. Paul de Saint-Victor dismissed it with these words: "Here line dissolves into licence; the protagonists have lost their limbs in the brawl, and retrieve and readjust them at random. Rebecca floats in the arms of her ravisher like a dress caught in the branches of a deformed tree. The Templar [Bois-Guilbert]'s slave stretches out a seven-league leg. The horse that he restrains belongs in Bestiary of heraldic art. A murky light… exacerbates the monotony of this grim scene." Step forward Baudelaire for the defence: "What is so admirable about *The Abduction of Rebecca* is the perfect coherence of the intense, compressed, serried, logical tones, the result of which is very striking. In almost all painters who are not colourists, one detects voids, great holes produced by tones which are not, as it were, on the right plane; Delacroix's art is like nature, it abhors a void."

A literary pretext could not mitigate Delacroix's next choice of subject, the murder of a bishop, and this was especially true under the reign of the pious Charles X. A scandal duly engulfed *The Murder of the Bishop of Liège* (p. 32). It is drawn from an episode in Sir Walter Scott's *Quentin Durward*. William de La Marck, the Wild Boar of the Ardennes, sits ensconced upon the episcopal throne in the midst of an orgy. The bishop is mockingly dressed in his sacred robes and his throat cut before the throne. What was more, the turbulent crowd that Delacroix placed around the bishop was inevitably reminiscent of the revolutionary hordes. Delécluze was quite carried away: "This little picture roars, bawls, blasphemes… The obscene songs of this drunken rabble of soldiers can

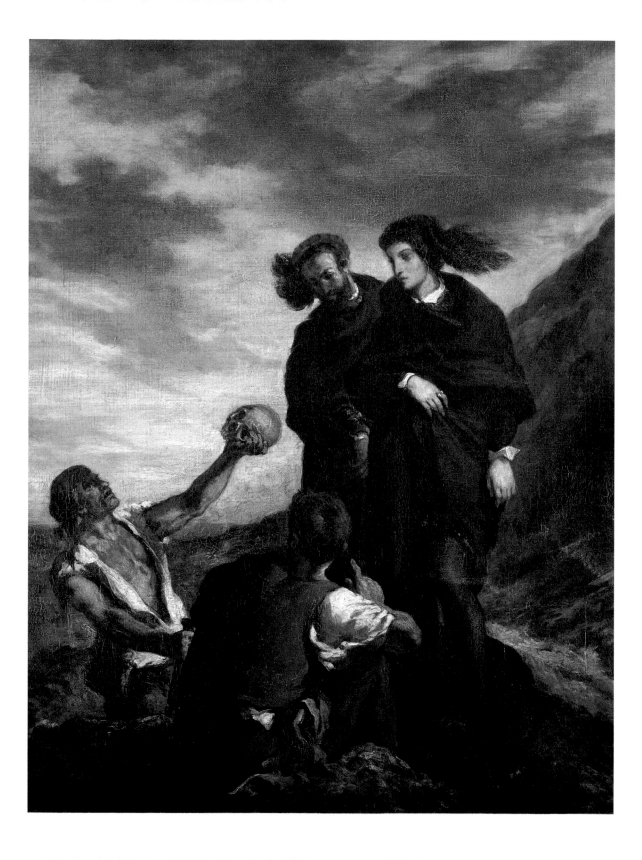

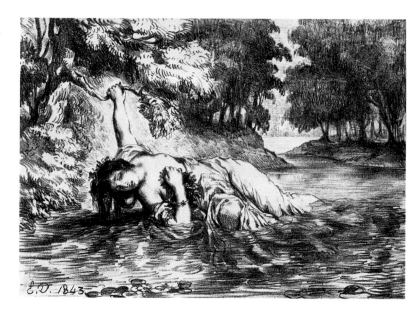

The Death of Ophelia, 1843
Lithograph, 18.1 x 25.5 cm
Paris, Musée Eugène Delacroix

be clearly heard. What brigand-like faces they have! … What a bestial, blood-thirsty joviality they display! How everything pullulates and yelps, how it blazes and stinks!" The choice of subject was, again, far from innocent, while the critics' invective emphasises how powerful was the resulting composition.

Delacroix discovered Shakespeare in 1825 on a trip to London, where the celebrated Edmund Kean was playing Richard III. In Paris, the equally famous Talma – whose town house was decorated by Delacroix – did much to popularise Shakespeare's work in French. Delacroix saw *Hamlet* in Paris, in the company of Hugo, de Vigny, Dumas, Nerval and Berlioz, and he agreed whole-heartedly with Hugo in his *Préface de Cromwell:* "Shakespeare *is* drama, and drama that combines in a single inspiration the grotesque and the sublime, the terrible and absurd, the tragic and the comic. This drama is the true character of the third epoch of poetry, the literature of today."

The Shakespearean hero, imperfect, immoderate and immature, was perfectly adapted to Delacroix's temperament, and gave free rein to his imagination; in his hands, the hero could be completed and perfected. It was, of course, Hamlet who most fascinated Delacroix. The Hamlet that he painted is faithful to the text; Baudelaire describes him as "delicate, wan, with pale, feminine hands, an exquisite sensibility, indolent, slightly indecisive, with a somewhat vacant gaze".

"Alas, poor Yorick! – I knew him, Horatio: a fellow of most infinite jest…" (Act V, Scene 1). The scene of *Hamlet and Horatio in the Graveyard* (left and right) inspired a painting and a series of lithographs which mirror the development of his art as a whole. As Alain Daguerre de Hureaux noted, "starting from the Romanticism of the first lithograph which makes extensive use of the accessories – castle, tombs, and funeral procession – he gradually internalises the scene and imparts a new dimension through his analysis of character".

A similar procedure comes into play in his *Death of Ophelia* (above). Touched by the story of her madness and death, he contrived to express in her

Hamlet and Horatio in the Graveyard, 1843
Lithograph, 28.3 x 21.4 cm
Paris, Bibliothèque nationale de France,
Cabinet des estampes et de la photographie

PAGE 40:
Hamlet and Horatio in the Graveyard, 1839
Oil on canvas, 29.5 x 36 cm
Paris, Musée du Louvre

Cleopatra and the Peasant, 1838
Oil on canvas, 98.4 x 122.7 cm
Chapel Hill (NC), Ackland Art Museum,
University of North Carolina at Chapel Hill

PAGE 43:
Medea about to Kill Her Children, 1838
Oil on canvas, 260 x 165 cm
Paris, Musée du Louvre

death-scene a Shakespearean tribute to the suffering of humanity. Again it is Baudelaire who best defines what Delacroix's heroines have in common: "In general, he does not paint pretty women, at least not from society's point of view. Almost all sickly, they are resplendent with a certain inner beauty. He does not express strength through size of muscle, but through tension of the nerves. It is not suffering *simpliciter* that he best expresses, but – such is the prodigious mystery of his painting – moral affliction. This high, serious melancholy radiates a grim brilliance, even in his use of colours, which is broad, simple, and abounds in massy harmonies, like that of all the great colourists. Yet it is plaintive and profound as a Weber melody."

Cleopatra and the Peasant (above) allows Delacroix to contrast beauty and ugliness, illustrating the mixture of the sublime and the grotesque that, in his view, typified Shakespeare's art. The source of the painting is indeed *Anthony and Cleopatra*, though certain critics have cited the name of Plutarch. This is the denouement; Cleopatra stares in fascination at the asp. As to the *Medea about to Kill Her Children* (p. 43), no heroine could better express the destructive power of women, a theme dear to the Romantics as it was to their successors, the Symbolists. Repudiated by Jason, Medea takes her revenge by killing the two children she has born to him; the subject is taken from Euripides' tragedy, *Medea*.

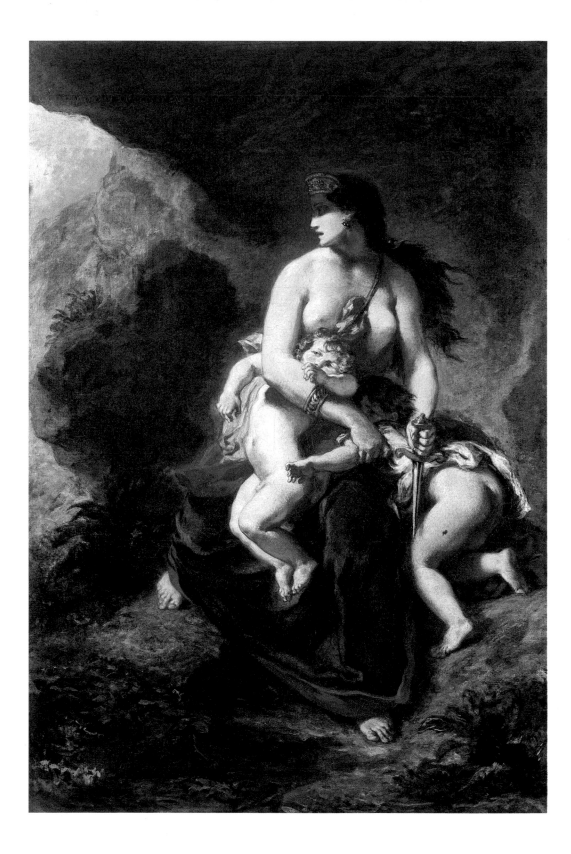

For once, the critics were convinced. Delécluze, Delacroix's sworn enemy, went so far as to compare the colours of the work, and particularly the right-hand child, to the *Jupiter and Antiope* of Correggio. It is startling to find that the influence of the Italian Renaissance, and especially of Leonardo's *Virgin of the Rocks*, was detected in the pyramidal composition. Delacroix had used the traditional image of Charity – a bare-breasted woman clasping her children to her breasts – to portray an infanticidal mother, but this, apparently, was acceptable. Some even suggested that the dagger in Medea's hand might serve to defend rather than slaughter her babes. Was this a sorceress or a goddess?

The Abduction of Rebecca, 1858
Oil on canvas, 105 x 81.5 cm
Paris, Musée du Louvre

PAGE 44:
Marfisa and Pinabello's Lady (detail), 1852
Oil on canvas, 82 x 101 cm
Baltimore (MD), The Walters Art Gallery

Christic on the Cross, study after Rubens, 1839
Graphite
Bremen, Kunsthalle

BELOW:
Peter Paul Rubens
Christ on the Cross (Le Coup de Lance),
1620
Oil on canvas
Antwerp, Koninklijk Museum voor Schone
Kunsten

BOTTOM:
Study after Rubens' *Christ on the Cross*
Pen and wash
New York, The Pierpont Morgan Library

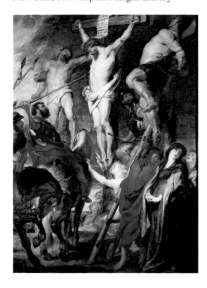

In *Marfisa and Pinabello's Lady* (p. 44), Delacroix found a pretext for painting a superlative nude. It illustrates an episode from Ariosto's *Orlando Furioso* (Canto XX). The invincible Marfisa forces Pinabello's mistress to hand over her clothing to an old woman whom she has scorned. The moral and physical striptease is reminiscent of Van Dyck's *Saint Martin Dividing His Cloak*, but Delacroix's principal concern was the representation of a nude seen from behind on a background of red and white satin.

There is no doubt that, unlike Michelangelo, Delacroix loved or at least needed women. His father died when he was seven, his mother when he was sixteen, and he was brought up by his sister; their relationship was a stormy one. At twenty, he complained that the "sweet warmth of love" offered no consolation, and he was constantly wary of any passion that might stand in the way of his art. Servant girls, *grisettes*, dancers at the Opéra and studio models failed to satisfy

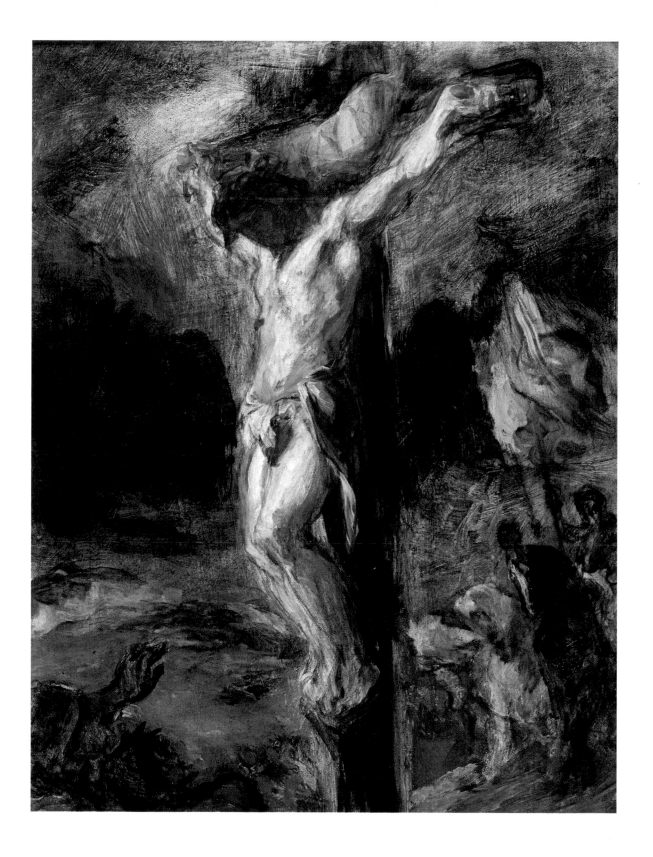

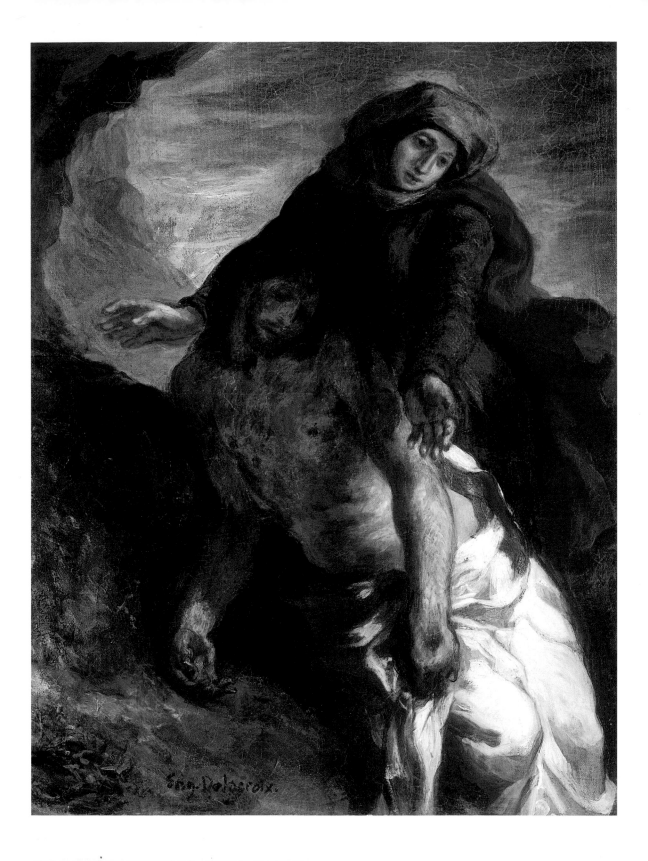

his craving for the ideal, the "superior" woman, but he showed little ardour in his search for this paragon. Many of his female admirers became his mistresses; the list includes Joséphine de Forget, Alberte de Rubempré, Elisa Boulanger, the beautiful Pauline Villot, la Païva, and the Princesses Colonna and Czartoriska. A cantankerous Breton, Jenny Le Guillou, brought the list to an end.

Was Delacroix the son of Charles Delacroix, Minister of Foreign Affairs under the Directory, or of Talleyrand, who succeeded Charles as Minister and was a close friend of the family? Partisans of the latter theory cite the constant support offered by the 'lame devil' Talleyrand and the protection that he gave Delacroix early in the artist's career. The physical resemblance of the two men and their similar personalities are also cited. Adolphe Thiers, Talleyrand's rival and Minister of the Interior during the reign of Louis-Philippe, continued this protection, which took the form of numerous state commissions. Whatever the truth of the matter, when Louis-Philippe created the Musée de l'Histoire de France at Versailles, two paintings were commissioned from Delacroix: *The Battle of Taillebourg* (pp. 34–35) and *The Entry of the Crusaders into Constantinople* (pp. 36–37). For these vast canvases, Delacroix was obliged to open a studio in the rue Neuve-Guillemin, and train his own assistants. This time, the critics were completely won over. The derring-do of Louis IX on his white charger riding down the English defences on the Taillebourg bridge and the famous capture of Constantinople (1204) acted as a balm after the terrible defeat of Waterloo. And yet Delacroix's method in these paintings is unchanged; again the implications of the event are focused in a single scene, again he shows the catastrophes of war and the women delivered over to the victors. His goal is not to describe the event – though the details are carefully researched and the armour and standards historically correct – but to make the spectator feel its emotional consequences. The inspiration flowing through these *'grandes machines'* is no less personal and romantic than it was in *The Barque of Dante* and *The Death of Sardanapalus.*

The reign of Louis-Philippe saw a return to the great tradition of French religious painting. Commissions were forthcoming. But what was Delacroix's attitude to religion? His writings reveal a mixture of Voltairian scepticism, aesthetic sensibility and diffuse spirituality. An enthusiastic reader of Diderot, he was, like Diderot's hero, *Jacques le fataliste,* unable to convince himself that his soul was immortal. Yet the existence of genius was a proof of the existence of God. Michelangelo himself might have subscribed these lines from Delacroix's *Journal:* "For light to burst forth from darkness requires that God light up a sun... The truth is revealed only to the genius, and the genius is therefore always alone." This is the profession of a Romantic faith, but not far from Michelangelo's belief that beauty leads upward to God, since from His hand it first came. Yet when Delacroix came to paint one of the most anguished representations of the crucifixion, his *Christ on the Cross* (pp. 46–47), it was to Rubens and his *Christ on the Cross (Le Coup de Lance)* (p. 46) that he returned. Baudelaire, in his 1846 Salon, is again the perfect interpreter. Analysing Delacroix's affinity with the image of the suffering Christ, he says: "The grave sadness of his talent perfectly suits our religion, which is a profoundly sad religion, a religion of universal suffering, and, precisely because of its catholicity, leaves the individual complete freewill."

PAGE 47:
Christ on the Cross (sketch), 1845
Oil on wood, 37 x 25 cm
Rotterdam, Museum Boijmans Van Beuningen

PAGE 48:
Pietà, c. 1850
Oil on canvas, 35 x 27 cm
Oslo, Nasjonalgalleriet

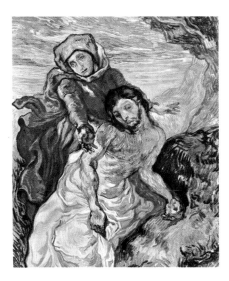

Vincent van Gogh
Pietà, 1889
Oil on canvas, 73 x 60.5 cm
Amsterdam, Van Gogh Museum

The picture is reversed relative to the Delacroix, as Van Gogh painted it at Saint-Rémy, using a lithograph in which the original is reversed, and painting the colours from memory.

The Charm of the Orient

When Hussain, the Dey of Algiers, struck the French consul Duval a blow with his fan, he little thought that he was triggering a French invasion. He was; Charles X adduced national dignity as a reason for military intervention, and this first colonisation campaign began in 1830. When Charles was overthrown in the Revolution of the same year, his successor, Louis-Philippe, saw in the Algerian war an opportunity to offset revolutionary mutterings, republican aspirations and institutional weakness with a succession of easy victories abroad. But the conflict must not be allowed to spread to Morocco. And an extraordinary mission was dispatched to allay the fears of the Sultan of Morocco, Moulay Abd-er Rahman, "supreme religious leader of the Mohammedans". Displays of French military power, notably the appearance in the straits of Tangier of the French warships *Suffren, La Béarnaise* and *La Railleuse*, meanwhile served to discourage any Moroccan military enterprise.

The chosen ambassador was Comte Charles Edgar de Mornay, a former gentleman of the bedchamber of Charles X. He was more famous as gentleman to the bedchamber of Mademoiselle Mars, a celebrated coquette who had held a leading role in Victor Hugo's *Hernani*. De Mornay was afraid that he would be bored, so Mlle Mars suggested that he should take a companion, her remarkable friend Eugène Delacroix: he was so admired in high society, spoke so eloquently about art and music, and had already painted lascivious oriental odalisques without benefit of experience. Moreover, he was an excellent horseman, and came with the highest recommendations. The minister was prepared to countenance this proposal. In the words of Maurice Arama, the author of a comprehensive study of Delacroix's voyage, "One could hardly refuse to an ambassador anxious to mitigate the discomforts of a voyage in hostile lands a travelling companion, especially one whose fame was in the ascendant, who was already a member of the Légion d'honneur, and who was rumoured to be of even more distinguished parentage…".

But the liberality of the Royal Treasury went no further than transport; Delacroix was to pay for his own food and other expenses. On January 1, 1832, at three in the morning, having seen the new year in with Mlle Mars, Mornay and Delacroix left for Toulon. Thence, on 11 January, the frigate *La Perle* set sail for Africa.

The events of the voyage are well known to historians, since not only did Delacroix keep his *Journal*, he was, at the same time, filling his albums with sketches (above) that constitute a pictorial narrative of the trip. (Of the four albums, the Louvre possesses three and the Musée Condé at Chantilly the fourth.)

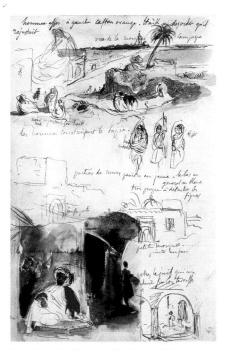

Page from the Moroccan Notebook, 1832
Watercolour, 19.3 x 12.7 cm
Paris, Musée du Louvre, Département des Arts graphiques

ABOVE:
Pauline Villot
Delacroix in a "burnous"
Pencil, 23 x 17 cm
Private collection

PAGE 50:
Women of Algiers in their Apartment
(detail), 1834

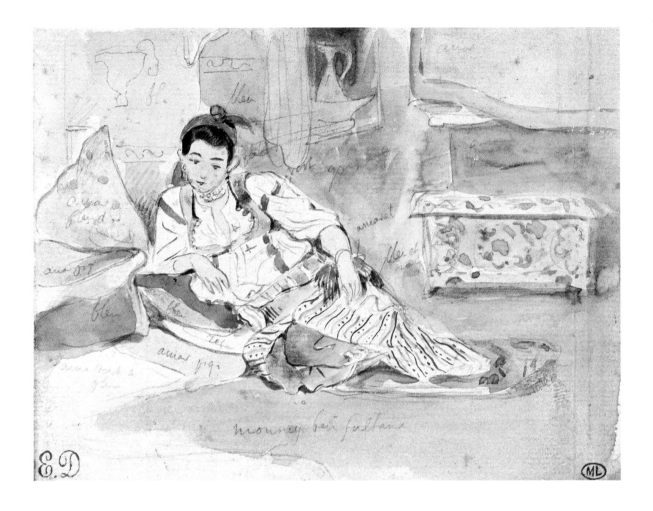

Sketch for the *Women of Algiers (Mounay ben Sultan)*, 1832
Watercolour over graphite, 10.7 x 13.8 cm
Paris, Musée du Louvre, Département des Arts graphiques

PAGE 53, ABOVE:
Women of Algiers in their Apartment, 1834
Oil on canvas, 180 x 229 cm
Paris, Musée du Louvre

They allow us to follow the artist day by day as he travelled from Tangier to Meknès and through Spain and Algeria, recording the festivals and other events that he encountered en route.

Delacroix was dazzled by Tangier. Here at last was the Orient of his dreams, the glittering martial Orient painted by Gros and Girodet, the lyrical Orient of the poets, Byron, Hugo and Lamartine. Here was the reality of the brocades and silks, the harnesses and damascene blades that he had borrowed from the painter-collector Jules-Robert Auguste when painting his great oriental canvasses. In Arama's words, it was above all the Orient of "Philhellenes …lamenting the departed glory of Greece and the ruins of the Parthenon".

The voyage to Morocco was a turning point in Delacroix's life as a painter. His vision underwent a transformation; Romantic élan gave way before this rediscovery of the classical world, its colours transformed by the intense Mediterranean light. He wrote to Pierret when the impact of this discovery was still fresh in his mind. "Imagine, my friend, what it is to see, lying in the streets or resoling worn-out shoes, persons of consular bearing; Catos, Brutuses, who wear that disdainful air that the masters of the world must once have worn. These people own no more than the blanket in which they walk, sleep and are

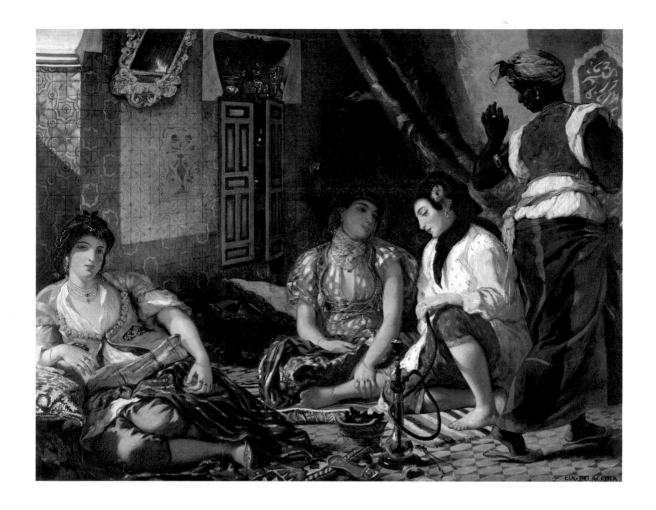

buried, and they seem as satisfied with themselves as Cicero must have been with his curule chair. I tell you, you will never believe what I shall bring back with me, because it will be so far beneath the truth and nobility of these characters. Antiquity has nothing fairer to show… All this in white like the Senators of Rome and the Panathenaic Festival."

The discovery of the Barbary sun was a salutary shock. Henceforth it was his Muse and example. In the *Women of Algiers in their Apartment* (pp. 50–53) and the *Jewish Wedding in Morocco* (p. 56), painted on his return to France, Delacroix applied the principles that he had elaborated in Morocco. He set these out in his *Notes for a Dictionary of the Fine Arts*: "Light is a veritable accident: all true colour consists in this – I mean colour that gives the impression of depth and of the radical difference that must distinguish one object from another." The result was shadows in which a multitude of reflected colours are registered by infinitesimal brush strokes. It was a highly controversial effect. For the Impressionists, Expressionists and Fauves who came after Delacroix, his technique was a revelation. For contemporary critics, it was a foible. Delécluze wrote: "The eye is irritatingly distracted by tiny strokes of red, yellow and blue applied at random, in a thousand and one contradictory directions." By contrast,

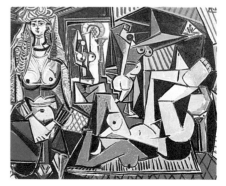

Pablo Picasso
Women of Algiers (after Delacroix), 1955
Oil on canvas, 114 x 146 cm
New York, collection Mrs Victor W. Ganz

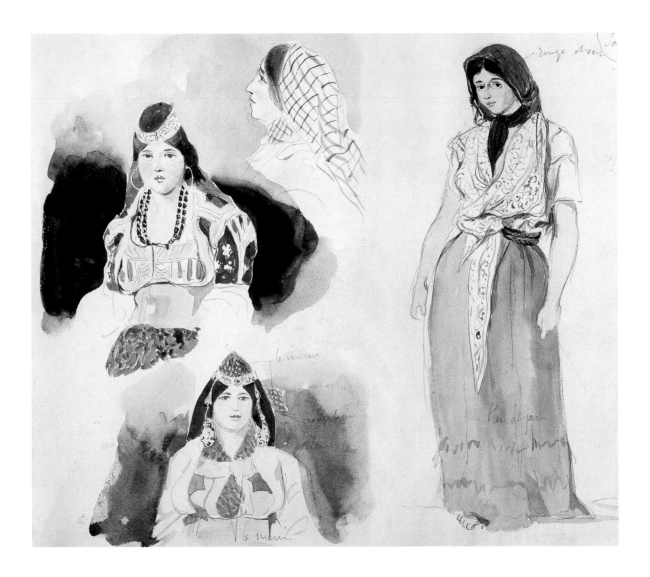

Moroccan Women, 1832
Watercolour
Chantilly, Musée Condé

in 1881 Seurat noted: "It is the very strictest application of scientific principles, seen through the medium of personality."

Delacroix was both fascinated and repelled by the spectacle of Morocco. It was an ambiguity that he resolved by finding there "the beauty of antiquity". "How beautiful! Like in Homeric times!" he said of the harem that inspired the first important painting to emerge from his voyage, the *Women of Algiers in their Apartment*. Through a network of friends, and by dint of careful planning, Delacroix was able to enter a harem without offending religious sensibilities. The harem was that of the *shaush* of the management of the port of Algiers. There he could observe and sketch the Muslim women in their domestic environment. In the women's apartments, at the sight of the "beautiful human gazelles amid this profusion of silk and gold", Delacroix was overcome by "an exaltation, a fever, which sorbets and fruits are barely sufficient to calm". "This is womankind as I understand it!" he exclaimed.

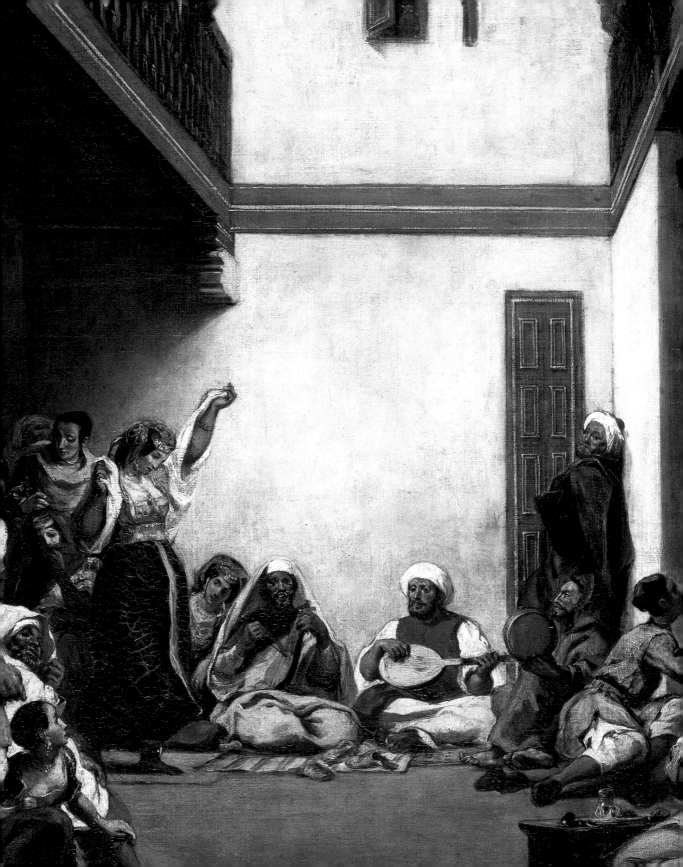

It is a composition remote from the tumult and tragedy of *The Death of Sardanapalus*. The serenity and silence of the painting are striking. The veiled light and rhythmic forms impart a strong sense of unity. When Cézanne came to copy the painting, he noted: "All these peppery shades, despite their violence, look what light and harmony they bestow. And he has a feeling for the human, for life in movement, for the heat. Everything moves. Everything shimmers. The light!" The light and colours that had made such an impression on Delacroix were transformed and tempered in the prism of memory.

The many pencil sketches and watercolours that he had made in situ served as studies for the *Women of Algiers*. He tells us: "I only began to do anything at all good, on my African trip, after I had forgotten the little details and could record in my paintings only the poetic and striking side of things. Till then, I was a prey to my love of exactitude, which the majority take for truth." Degas too reflected on this: "It's excellent to copy what one sees, but it's much better to draw from memory what one can no longer see. It is a transformation in which ingenuity collaborates with memory. You reproduce only what struck you, that is, only what is needed. Then your memories and imagination are free of the tyranny of nature. Which is why paintings made in this way, by a man with a cultivated memory and who knows the masters, are almost always remarkable works. Witness Delacroix."

The art dealer Vollard asked Renoir: "For you, Delacroix's the man?" Renoir replied, "By nature, obviously, I incline to Delacroix... the *Women of Algiers* – it's the most beautiful painting in the world... His women are really Oriental... The one who has a little rose in her hair... And the negress! She really moves like a negress! That painting savours of seraglio incense: when I am in front of it, I imagine I'm in Algiers."

For the rest of his life, Delacroix continued to draw on this wealth of notes and memories. In them, impression jostles with impression, all set down pell-mell, one on top of another. From them he took subjects, ideas, and details that he orchestrated, transformed and varied in memory.

The principal characteristic of Delacroix's draughtsmanship is the sense of speed in every least stroke of his pencil. Baudelaire quoted Delacroix as saying "If you're not able to sketch a man who throws himself out of the window in the time it takes him to fall from the fourth floor to the ground, you'll never be able to produce great paintings". Delacroix is a master of the instantaneous, the photographic, yet if his pencil is a lens, it is one which also conveys the emotions transmitted to the brain by the optic nerves. Consequently few of his drawings are finished works like those of Ingres; in Théophile Gautier's comparison, "In the matter of draughtsmanship, Delacroix is fire to Ingres' ice."

The number of major paintings that derive from Delacroix's Moroccan notes and sketchbooks is clear proof of the impact of the experience. They include the *Jewish Wedding in Morocco, The Fanatics of Tangier* and *The Sultan of Morocco and his Entourage*. In the composition of these works, Delacroix scrupulously observed the notes and sketches that he had made in situ. Thus the décor of the *Jewish Wedding in Morocco* exactly matches that recorded in a watercolour in the notebook, while his notes give an exact description of the painting that was to come.

For he did indeed attend a Jewish wedding during his stay in Tangier. Something similar is true of the scene depicted in *The Fanatics of Tangier*

PAGE 56:
Jewish Wedding in Morocco
(detail of the interior), 1837–1841
Oil on canvas, 105 x 140.5 cm
Paris, Musée du Louvre

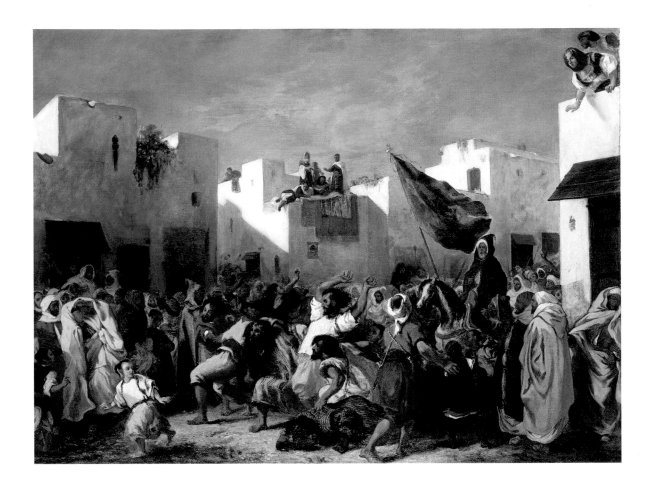

The Fanatics of Tangier, 1837–38
Oil on canvas, 97.8 x 131.3 cm
Minneapolis (MN), The Minneapolis
Institute of Arts

PAGES 60/61:
Lion Hunt, 1855
Oil on canvas, 56.5 x 73.5 cm
Stockholm, Statenskonstonstmuseer

(above); Mornay and Delacroix witnessed it through the shutters of an upper-storey window, in either Tangier or Meknès. The subject is difficult to understand, and Delacroix offered an explanation in the brochure for the 1838 Salon: "These fanatics are called Issaouis, after their founder Ben Issa. At certain times of year, they meet outside towns; then, their enthusiasm excited by prayers and wild cries, they enter into a veritable state of intoxication, and, spreading through the streets, perform a thousand contortions, and even dangerous acts."

The *Sultan of Morocco and his Entourage* (p. 59), painted in 1845, was intended to immortalise the Comte de Mornay's diplomatic mission, his successful meeting with the Sultan. In fact, Delacroix scorned the opportunity to commemorate an event doomed to oblivion. Instead, he concentrated on creating a spectacular open-air scene in bright light, with vivid colours and monumental protagonists. Exemplifying his orientalising vein, it also exhibits the full wealth of his technical mastery. The critics were unanimous in their praise. Thoré, in his annual report on the Salon, wrote: "This time no one will accuse the painter of *The Massacre of Chios* of distorting his characters or exaggerating their movements. All the figures are calm and noble, as tranquil Orientals should be. Delacroix has attained to one of the highest points in art: magnificence and grandeur in simplicity!"

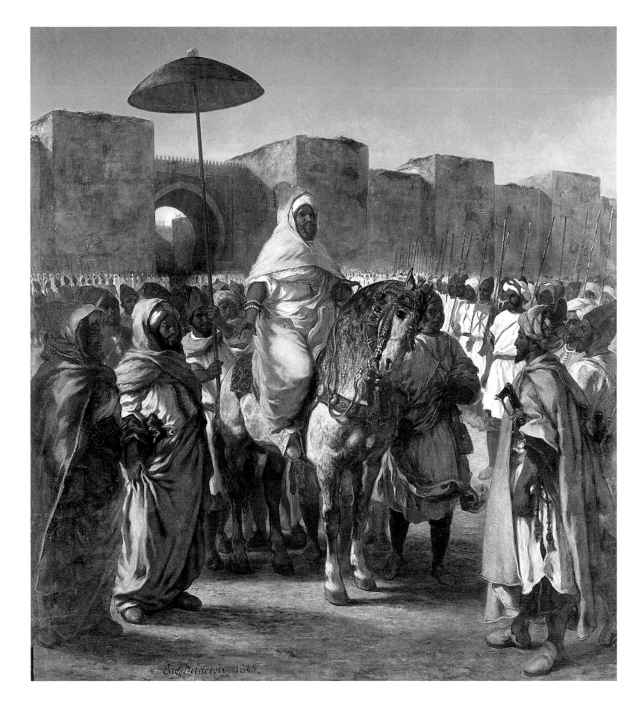

Géricault had inspired in Delacroix his fascination with horses, those intermediaries between man and nature. They are the emblematic beasts of Romantic painting: we find them rearing up in the nightmares of Fuseli, adorned with the saddle of Mustapha in Gros, or disputing the Epsom Derby in Géricault. "It's essential to master horses. One should go to a stable every day…," he noted in his *Journal* of 1823. For Delacroix, the horse was the incarnation of the wild ardour

The Sultan of Morocco and his Entourage, 1845
Oil on canvas, 384 x 343 cm
Toulouse, Musée des Augustins

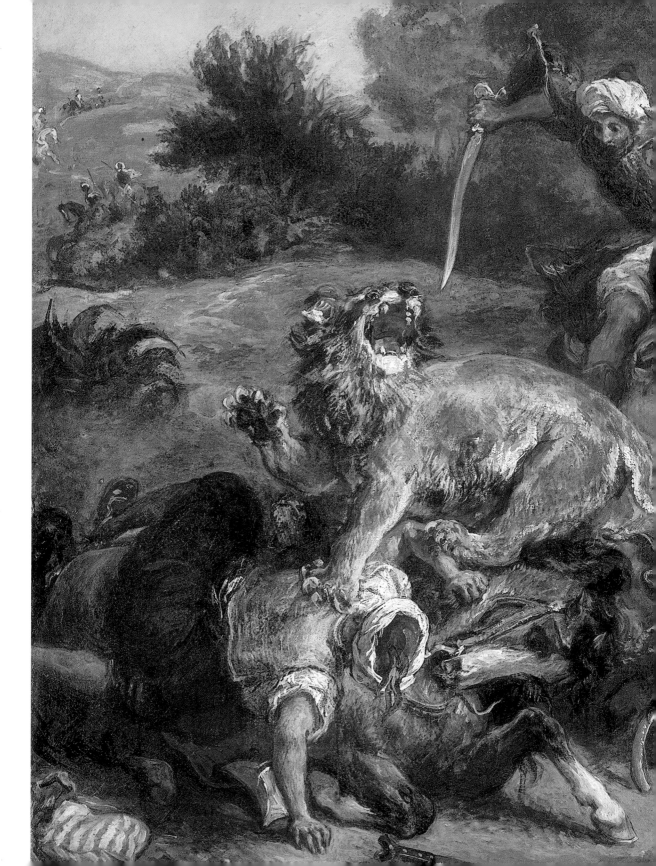

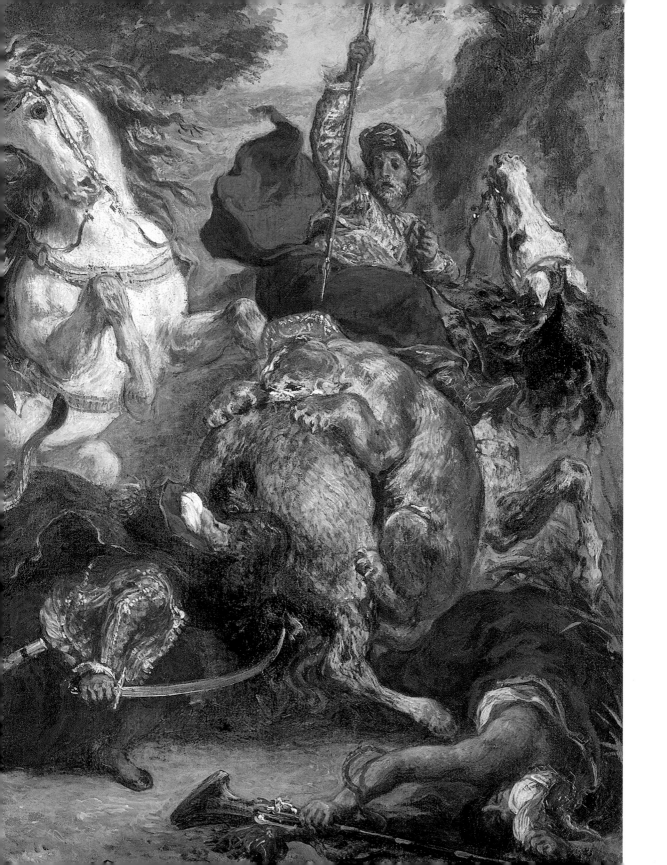

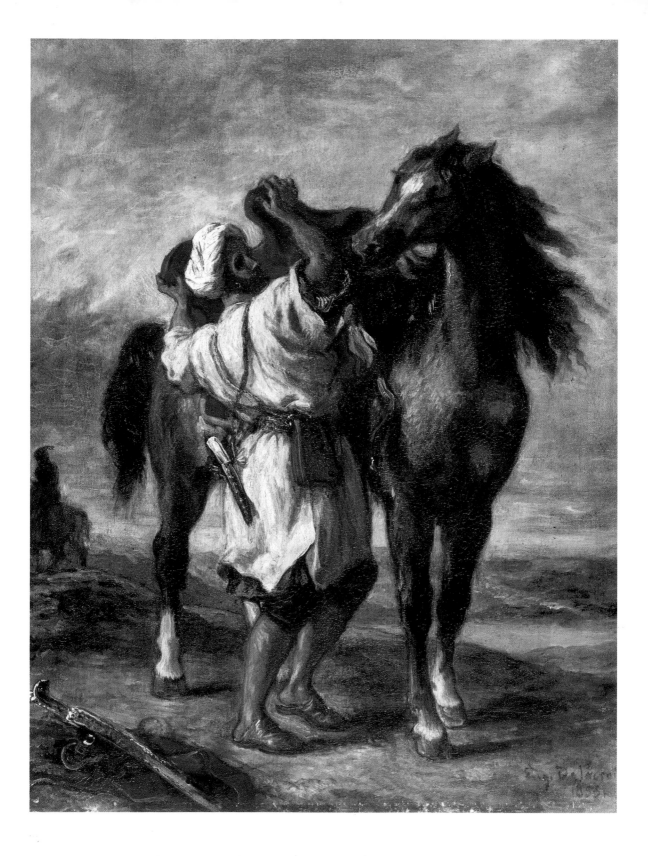

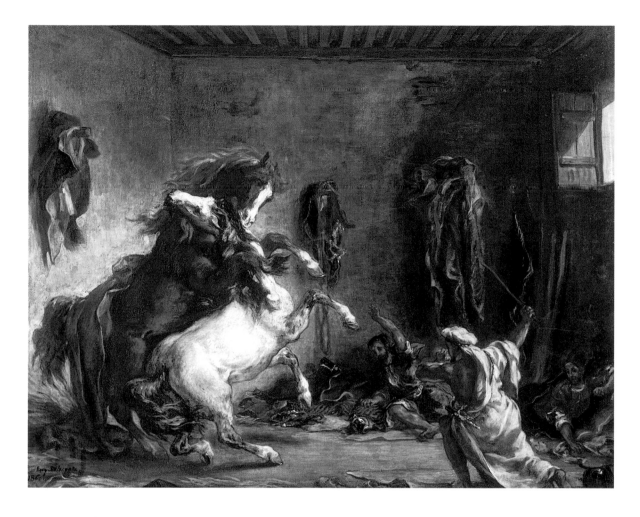

of youth launching out in the quest for glory, and he depicted it thus throughout his œuvre, from *The Battle of Taillebourg* (pp. 34–35) to the ceiling of the Apollo Gallery in the Louvre (p. 66). But his love of horses was fully satisfied only in Morocco. Thereafter the Arab horses that he had seen and drawn during his voyage constituted a kind of repertoire. For one of his last paintings, *Arab Horses Fighting in a Stable* (1860, above), he drew on a scene that he had witnessed in Tangier, when the horses of Mornay and the English Consul were fighting. "There I saw everything that Gros and Rubens could imagine in their most light and fantastical vein," he wrote. No anatomical studies lie behind this painting. Once again, it is the violence of the combat that he portrays; the power and energy of the animals, an effect emphasised by the strong contrasts of light and shade.

Wild animals fascinated him: "Tigers, panthers, jaguars, lions! Whence come the feelings such things inspire in me?" He visited the Pasha's zoo and, in Paris, observed and drew the big cats of the Jardin des Plantes in the company of his friend, the animal sculptor, Barye. Though when he wanted to depict a tiger, he was often content to allow his own cat to model... He explained this attraction to himself in his *Journal*: "The true man is a savage; he is at one with nature

Arab Horses Fighting in a Stable, 1860
Oil on canvas, 64.6 x 81 cm
Paris, Musée du Louvre

PAGE 62:
Arab Saddling his Horse, 1855
Oil on canvas, 56 x 47 cm
Saint Petersburg, Hermitage

A Young Tiger Playing with its Mother, 1830
Oil on canvas, 131 x 194.5 cm
Paris, Musée du Louvre

Delacroix frequently went with his friend, the animal sculptor Barye, to see the big game in the Jardin des Plantes. But mostly he was content to observe his own cat…

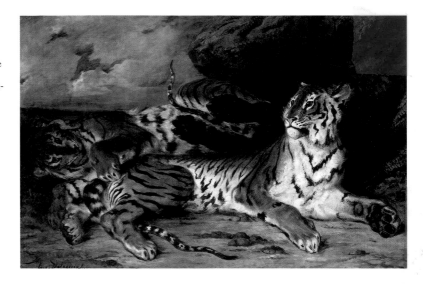

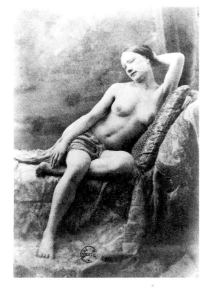

Academy figure
Calotype by the photographer Eugène Durieu (1800–1874) in collaboration with Delacroix
Paris, Bibliothèque nationale de France, Cabinet des estampes et de la photographie

PAGE 65:
Odalisque, 1857
Oil on wood, 35.5 x 30.5 cm
Private collection

This is the only known case of Delacroix transforming a banal photographic study into the odalisque of Orientalist dreams.

as it is… Men are tigers and wolves driven to destroy one another." Théophile Gautier saw a resemblance between Delacroix's face and manner and those of the lions that he painted: "His tawny eyes, with their feline expression, his slender lips stretched tight over magnificent teeth, his firm jaw line emphasised by strong cheekbones… gave his features an untamed, a strange, exotic, almost alarming beauty."

"The primary merit of a painting is to be a feast for the eye," Delacroix recorded in his *Journal* of 1863. The dazzling *Lion Hunt* (pp. 60/61) entirely fulfils this requirement. In Baudelaire's words, it is "an explosion of colours" that compels admiration. These animals roar with the colours of Van Gogh, even if Rubens, with his hunting scenes, is an ever-present influence. If any work ever announced Fauvism and Expressionism, it is the *Lion Hunt*.

For Delacroix, "nature is a vast dictionary. Painters who follow their imagination seek in the dictionary the elements that will accommodate their conception… Those who have no imagination copy the dictionary". Delacroix used his rapid sketches to constitute such a dictionary. But photography, which was quicker still, had just come into being. Generally critical of scientific progress, Delacroix was willing "to countenance the daguerreotype as an adviser, as a dictionary", but not to make of it "the painting itself". He was attentive to anything that might enrich the painter's craft, and was a founder member of the Société d'héliographie founded in 1851. With his friend Eugène Durieu, he made daguerreotype studies of nude models, which he then sketched again and again. But in his entire corpus, only one case is known of a banal daguerreotype nude becoming, under the magnifying lens of his Moroccan experience, an exotic *Odalisque* (left and right).

64

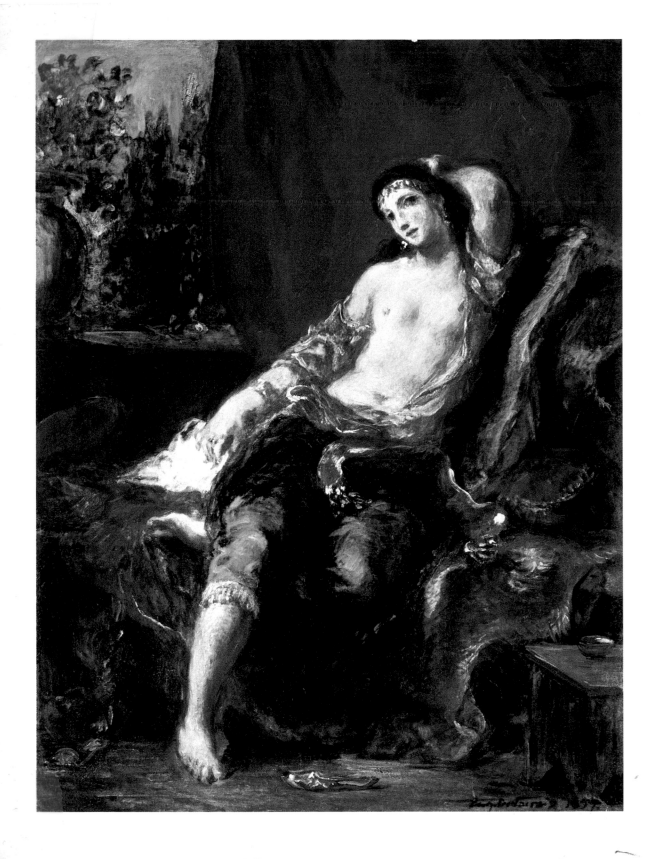

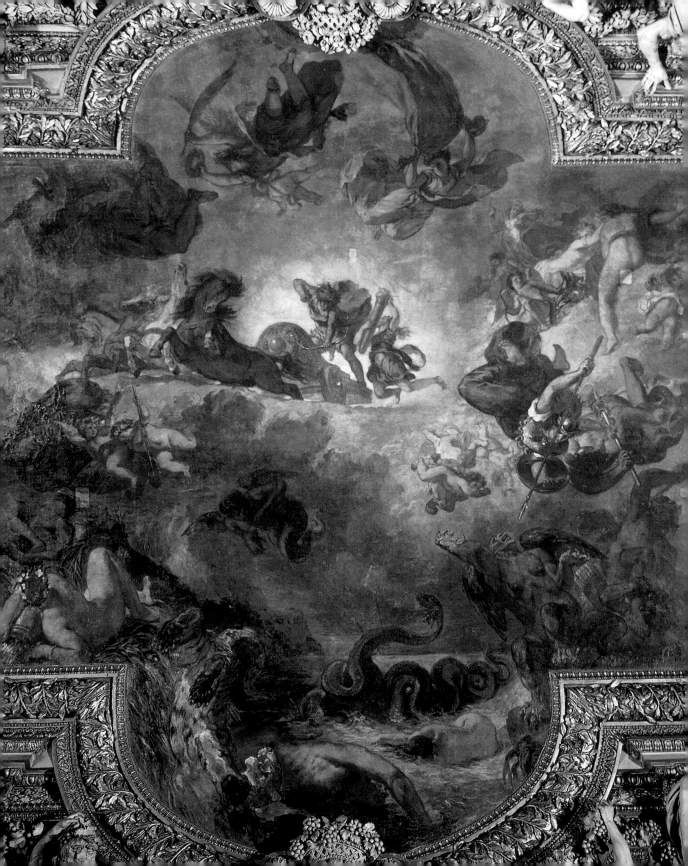

Commissioned to Greatness

In 1822, a young journalist reviewed *The Barque of Dante* for *Le Constitutionnel*. "No painting so clearly heralds the advent of a great painter as that of M. de Lacroix [sic]... He hurls down his figures, gathers them in groups, and bends them to his will with the boldness of Michelangelo and the fecundity of Rubens... I am not, I think, mistaken: M. de Lacroix has received the gift of genius. Let him progress with confidence, let him undertake immense works, for this is the indispensable condition of talent..." The name of this prophetic journalist was Adolphe Thiers; eleven years later, as a minister, he was able to offer Delacroix the chance to undertake just such works by commissioning vast decorative schemes on behalf of the French state. Delacroix, fresh from his Moroccan journey, was now equipped with a formidable repertoire of subjects, themes, forms and colours, and ripe for the execution of ambitious projects.

By a decree dated 31 August, 1833, Delacroix was commissioned to undertake his first state decoration, that of the Salon du Roi or Throne Room of the Palais Bourbon. "The Secretary of State for the Department of Trade and Public Works decrees as follows: M. Delacroix is commissioned to execute the paintings in the Salon du Roi of the Chambre des Députés. For this work is assigned the sum of thirty thousand francs payable by installments [sic] according to the progress of the work and to be deducted from the budget allocated to the works on the Chamber. A. Thiers." Delacroix was eventually awarded five thousand francs in addition to the thirty thousand specified. He owed a great deal to Thiers; as Delacroix himself wrote, the commission had been granted "despite the charitable advice of my enemies and even my friends, who told him [Thiers] that it was no favour to me, given that I had no understanding whatsoever of monumental painting and that I would dishonour the walls that I painted". *Le Constitutionnel* added to the chorus of protest: "... and it is a painter so unconcerned with glory, so uncertain of the value of his work, that has been chosen, and chosen on such sketches – the merest indications of his thoughts – to decorate an entire room in the Chambre des Députés, it is to such a painter that one of the greatest commissions for monumental painting of our day has been granted. Truly, in this case, the minister is not merely responsible, he is all but compromised".

Delacroix was immensely grateful to Thiers: "You have offered me, purely out of friendship, one of those decisive opportunities which open up to an artist a whole new career and which must necessarily elevate him to greatness, if they do not merely demonstrate his incompetence." And Thiers' patronage did not end there; this was merely the first of a succession of major commissions, on

Odilon Redon
The Chariot of Apollo, 1905–1914
Oil with pastel on canvas, 91.5 x 77 cm
Paris, Musée d'Orsay

"It is the joy of broad daylight contrasted with the sadness of night and darkness, like the joy of returning calm after anguish..."
O. Redon

ABOVE:
Sketch of Lions (detail after Rubens' *Lion Hunt*)
Graphite, 11.8 x 20.8 cm
Paris, Musée du Louvre, Département des Arts graphiques

PAGE 66:
Apollo Slays Python, 1850–51
Oil on mounted canvas, 8 x 7.5 m
Paris, Musée du Louvre (Galerie d'Apollon)

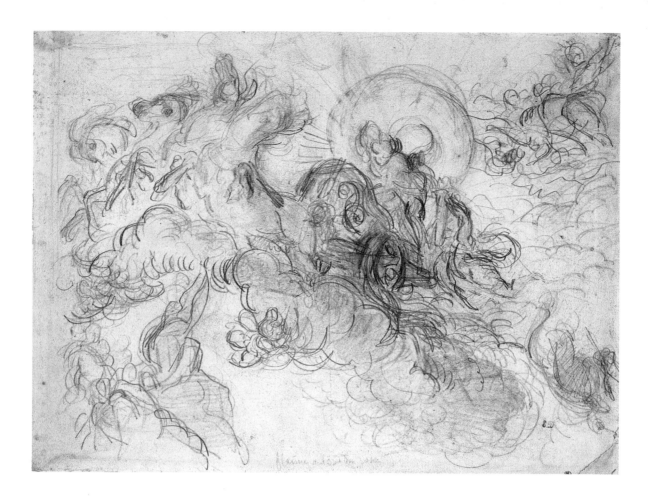

Apollo Slays Python
Drawing, 27.2 x 44 cm
Paris, Musée du Louvre, Département des
Arts graphiques

which Delacroix continued to lavish his talents until illness intervened. Between 1833 and 1854, Delacroix's monumental compositions spread across the Salon du Roi, the Library of the Palais du Luxembourg, the Galerie d'Apollon in the Louvre and the Salon de la Paix in the Hôtel de Ville. Baudelaire observed that "Painters had long since, as it were, unlearned the genre *decoration*". Delacroix could therefore innovate; he was finally in a position to dialogue on equal terms with his illustrious predecessors, the great masters of decoration, Michelangelo, Rubens, and Veronese. This was a different matter from even the largest easel paintings. Delacroix had now to exercise his imagination on huge surfaces of very various shape: domes, ceilings, semidomes, friezes, pilasters, and coffering. The essence of decorative painting is unity with the architectural framework that it invests. It was this aspect of the commissions that offered Delacroix the greatest opportunity for experiment and enabled him to give of his best. "My heart beats faster when I find myself before great expanses of wall that I must paint," he recorded in his *Journal*.

Like Michelangelo when he began the decoration of the Sistine Chapel, Delacroix knew nothing about the technique of fresco. In 1821, he had decorated the dining-room of the actor Talma, but this involved just four paintings of the seasons. So before executing the first commission, Delacroix spent several

PAGE 69:
Apollo Slays Python (detail)

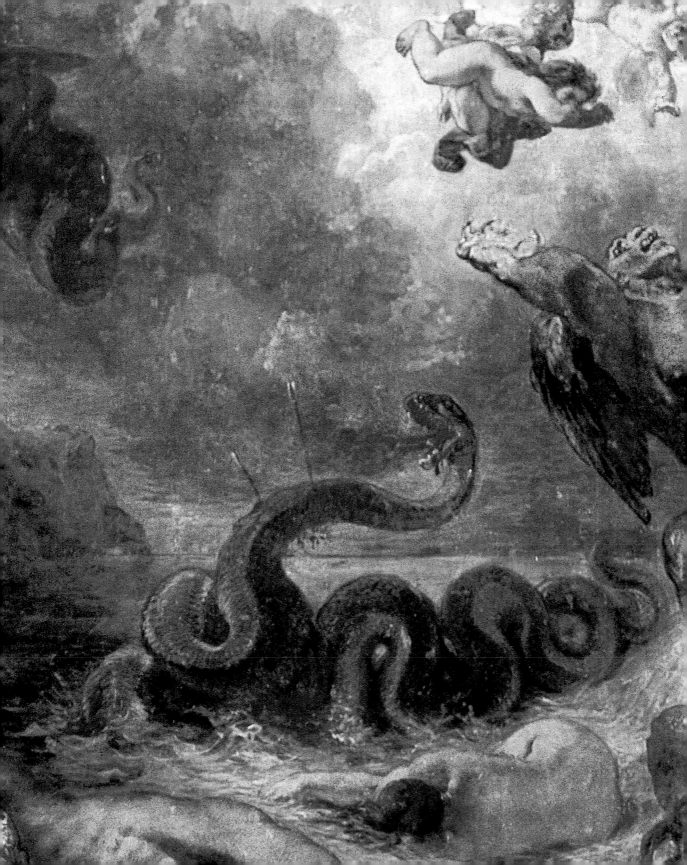

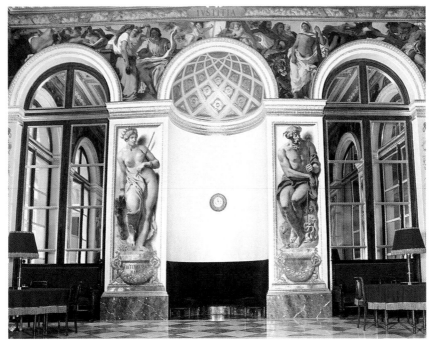

weeks with his family in the abbaye de Valmont, in Normandy, experimenting with fresco. Between 7 September and 10 October, 1834, he frescoed the walls of the abbey with three rather clumsily executed but finely coloured classical scenes: *Anacreon, Leda and the Swan,* and *Bacchus.* These experiments enabled him to invent his own technique. Aware of the limitations of distemper, and noting that fresco did not easily adapt to "our climate, in which the air is very damp", he decided to paint the walls of the Salon du Roi with oil, to which he added a little colourless wax or encaustic. This allowed him to imitate the matt surface of fresco and protect the colours from the effects of damp; it also made it possible to retouch his work, which the use of distemper would have ruled out. This was the technique that he used for all subsequent decorations.

Justice, 1833–1837
2.60 x 11 m
The Mediterranean, 3 x 1.22 m
Ocean, 3 x 1.18 m
Oil and virgin wax on plaster
Paris, Palais Bourbon, Salon du Roi, west wall

ABOVE:
Justice, 1833–1837
Oil on mounted canvas, 1.4 x 3.8 m
Paris, Palais Bourbon, Salon du Roi

PAGE 70:
Justice (detail), 1833–1837

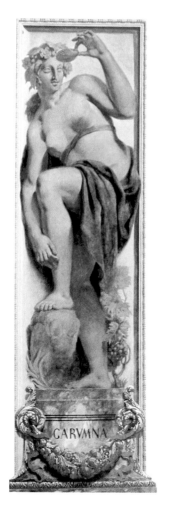

The Garonne, 1833–1837
Oil and virgin wax on plaster, 3 x 1.1 m
Paris, Palais Bourbon, Salon du Roi, south wall

Throughout 1837, Delacroix worked alone on the Salon du Roi, accepting assistance only for certain ornaments, and in 1838, the public could finally admire the finished work. It comprised four large sections of a coffered ceiling each decorated with a large allegorical figure in classical dress: *Justice, Agriculture, Industry* (which replaced his first thought, *Commerce*) and *War*. In addition, there were four little coffers representing *Putti bearing emblems*. On the pilasters, he personified the rivers of France and the seas or oceans that they flow into, such as *The Garonne* (left) and *The Mediterranean* (p. 73). A frieze running round the upper wall above the windows and doors echoes these themes, contrasting the evils of war (above) with the virtues of justice, industry and agriculture.

The critics were compelled to retract and admire. Planche himself wrote: "Who knows whether M. Delacroix would ever have discovered his particular talent for decorative painting, had the opportunity not been offered him by M. Thiers?" He added: "The decoration of the Salon du Roi constitutes a refutation of M. Delacroix's detractors. No one will any longer be able to deny that this eminent artist possesses both grace and elevation of style. Those… who persisted in denying that this painter understands the great Italian masters have now lost their case. The *Women of Algiers* and *Saint Sebastian* had already demonstrated to the percipient that M. Delacroix was not confined to harking back to the Flemish school, and that he appreciated Veronese and Titian no less than Rubens and Rembrandt… We have long been accustomed to see him as a pioneer exponent of pioneering themes; in the Salon du Roi, he has proved himself a pioneer in his treatment of a classical theme. The power to which it is such striking testimony is the preserve of those who combine imagination and an independent will."

Historians of art have had a field day enumerating the many reminiscences in the decoration of the Salon du Roi. They form part of the 'dictionary' that Delacroix had constituted for his own use, and a recreation in his own colours and forms of illustrious works from the past. Thus, in the frieze of *Agriculture*, Bacchus seems to have been directly inspired by a Grecian low relief. In the frieze of *Industry*, the naiads and Tritons have been compared with those of François Boucher, the great master of the genre. In the frieze of *Justice* (p. 70),

the old man offers a clear parallel with the *Prophet Jeremiah* in the Sistine Chapel. Finally, the nude slave-woman of the *War* frieze clearly owes much to the brilliant flesh-tones and rapid brush work of Delacroix's much-admired Rubens. But Delacroix also drew on his own earlier work, such as *The Massacre of Chios* and *The Death of Sardanapalus*, along with the many sketches made during his visit to Morocco and Algeria. Thus, in the *Justice* coffer, the woman with a child in her arms was imported directly from *The Massacre of Chios*, while the two chained and bare-breasted women of the *War* frieze are very close to the slaves of *The Death of Sardanapalus*. Finally, the three judges in the *Justice* frieze (p. 70) closely resemble a group of Arabs sketched in Africa, and the woman standing beside the judges is modelled on the woman dancing in the *Jewish Wedding in Morocco*.

Delacroix's greatest virtuosity, however, was reserved for a different project. It came in 1850, between the decoration of the Senate and Palais Bourbon libraries and the monumental Salon de la Paix at the Hôtel de Ville, and was the most important commission of Delacroix's life. The resulting work exercised a huge influence over Delacroix's successors, from Cézanne to Moreau and Redon. It was nothing less than the decoration of the Galerie d'Apollon in the Louvre. Following a fire, Le Vau had reconstructed this historical gallery for Louis XIV, while the decoration was entrusted to Charles Le Brun. Then in 1678, Louis left Paris for Versailles, and work ceased. In 1793, in the wake of the French Revolution, the Louvre became a museum, and the Second Republic deemed the completion of the decoration a republican duty.

Le Brun had intended a subject dear to the heart of the Sun King: Apollo on his chariot. For Delacroix, to make his mark at the very heart of the Louvre – that temple to the masterpieces of all time – and to do so not by exhibiting paintings but by decorating the central part of a ceiling was a thrilling opportunity. That he was taking up where Le Brun – one of his favourite artists – had left off, merely added to the challenge. To decorate the walls of national palaces was one thing; to enter into dialogue with the great tradition and rival its masters by creating a masterpiece of his own was quite another. As he wrote to George Sand, "This will tell people what they are waiting to find out – whether I am a painter or a dauber." Before he began, he felt the need to study the works of Rubens in

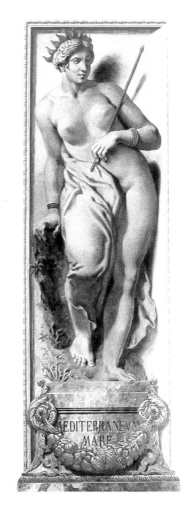

The Mediterranean, 1833–1837
Oil and virgin wax on plaster, 3 x 1.22 m
Paris, Palais Bourbon, Salon du Roi, west wall

Sketch for *Attila, horseman brandishing a weapon*
Pen and brown ink on paper, 17.7 x 22 cm
Paris, Musée du Louvre, Département des Arts graphiques

PAGE 72, ABOVE:
War, 1833–1837
Oil on mounted canvas, 1.4 x 3.8 m
Paris, Palais Bourbon, Salon du Roi

PAGE 73, ABOVE:
Study for the *War* coffer
Pen and brown ink on paper, 21.6 x 41.4 cm
Paris, Musée du Louvre

PAGE 75:
Attila and His Hordes Overrun Italy and the Arts (detail), 1843–1847
Oil and virgin wax on plaster, 7.35 x 10.98 m
Paris, Bibliothèque du Palais Bourbon

Combat of the Giaour and the Pasha
Lithograph, 36 x 25 cm
Paris, Bibliothèque nationale de France, Cabinet des estampes et de la photographie

Belgium and Flanders. He noted in his *Journal*: "'Painstakingly do everything that can make you great,' was poor Beyle [Stendhal]'s advice. This reflection helps me put up with the tedium of leaving for Belgium."

On his return, he exclaimed: "Those splendid Rubens have filled me with ardour." The ardour sought expression in the ceiling, which Cézanne found overwhelming. "It is a storm of lyricism, the upsurge, the dawn of our renaissance… The ascension, the flight of the world toward the sun, envy falling by its own weight, these monsters. And what imagination!" In his *Apollo Slays Python* (pp. 66–69), Delacroix retained Le Brun's ambition to portray the mythological figure of Apollo in the gallery of that name. But Delacroix enhanced Le Brun's allegory with a further allegory close to his own heart: intelligence wrestling with barbarity and light struggling with darkness. In his own formulation: "The god, standing in his chariot, has already launched some of his arrows… Pierced by these shafts, the blood-stained monster writhes as he exhales in a flaming vapour what remains of his life and impotent rage."

By emphasising the contrast between the two parts of his composition, the world of the sun above and that of darkness beneath, Delacroix transformed Le Brun's project and raised it to the plane of an eternal symbol. Without breaking with tradition, he was able to revolutionise the theme, opening it up to his successors; both Gustave Moreau in his *Phaethon* and Odilon Redon in his *Chariot of Apollo* owe much to Delacroix's example.

The subject, which Delacroix took from Ovid's *Metamorphoses*, is effectively the victory of Good over Evil. But it takes the form of beauty vanquishing the ugly and genius dispelling stupidity. Faced with a Delacroix triumphant as

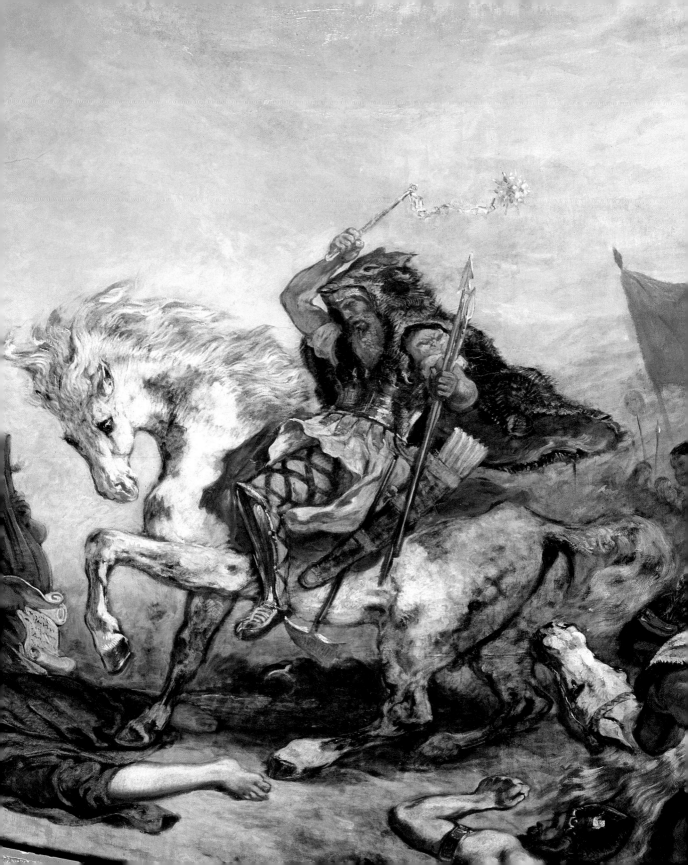

the Apollo he depicted, even Delécluze laid down his arms: "There could be no more appropriate application of the talent of M. Delacroix than in commissioning him to undertake this vast work… The brilliance and solidity of colour, pre-eminent qualities in the painter of the victorious Apollo, have been put to marvellous use on this… occasion. Throughout the work there reigns a harmony made up in equal parts of strength and finesse, that captivates all who have eyes to see." It goes without saying that Delécluze nonetheless launched some shafts of his own, ridiculous as they seem today: "…one must nonetheless regret that M. Delacroix did not more attentively study the nature and form of the animals that he has depicted in this latest composition. There is, for example, a tiger, seen from below, whose four limbs are not easily distinguished. And finally, the serpent Python, despite its mythological origin, should nonetheless possess a spinal column constituted like those of other reptiles of its species… vertical parallel coils are not possible for these animals; they coil only horizontally".

For his part, Ernest Vinet was concerned about the bad influence that Delacroix would have on his successors: "It is now two years since M. Delacroix's ceiling was revealed to the public gaze… Everyone is agreed that M. Delacroix is a prince among our colourists; a school has formed in his wake. The undisciplined gangs who, for more than twenty years, have, in their supposed quest for movement and colour, sunk ever further into barbarism, acknowledge in him their chief." Alas, what would Vinet have said, had he seen Matisse, the Fauves, and Chagall…

Meanwhile, Delacroix had discovered "a few feet of wall to paint… which should satisfy the craving to do things on a large scale, a hunger exacerbated by experience". The "few feet of wall" formed part of the library of the Palais Bourbon: two great semidomes eleven metres by eight (36 x 26 ft) situated on either side of the room. Delacroix decided to decorate them with allegorical subjects, one representing barbarity, *Attila and His Hordes Overrun Italy and the Arts* (p. 75), and the other civilisation: *Orpheus Civilizes the Greeks.* There were in addition "five little domes or bays", which would "present the divisions adopted in all libraries, while not following the classification too exactly: Sciences, Philosophy, Legislation, Theology and Poetry".

Once again, by making such a striking contrast between his two allegorical subjects, Delacroix contrived to symbolise War and Peace, the two poles of human conduct. The critics perceived this intention, but were somewhat overawed by the ambition and grandeur of the cycle. Paul de Saint-Victor, for example, wrote in *La Presse* (1863): "Between Orpheus and Attila, between the dawn and the twilight of the classical world, there is the entire history of civilisation and its genius. This history does not follow a chronological order: its conception is loftier and its plan more vast… It is a poem by turns Greek, Roman, Biblical, and Oriental, in which all ideas are engendered, all images lead into one another, despite the mutation of times and races, and of which every symbol is personified with a historical sagacity only equalled by the pictorial imagination that created it."

The success of the *Apollo* had taken Delacroix somewhat unawares; he was not used to a (favourable) critical consensus. He made the most of it by applying for and obtaining the commission to decorate one of the Salons of the new Hôtel de Ville. This was to be his last work of non-religious monumental painting. It is also, alas, the only one not to have survived; it perished when the town hall

PAGE 76:
Sketch for *Peace Descends to Earth*, 1852
Oil on canvas, 77.7 x 55.1 cm
Paris, Musée du Petit Palais

St. Michael Defeats the Devil, 1854–1861
Oil and wax on mounted canvas, 4.41 x 5.75 m
Paris, Saint-Sulpice

PAGE 79:
Jacob Wrestling with the Angel (detail),
1854–1861
Oil and wax on plaster, 7.51 x 4.85 m
Paris, Saint-Sulpice

burnt down during the Commune in 1871. Of the two Salons of this new build-
ing, the north facing Salon de la Paix fell to Delacroix; the south salon was com-
missioned from Ingres. We know little about Delacroix's scheme of decoration,
only that, even when aided by his two assistants, Pierre Andrieu and Louis
Boulangé, it took him two years of what he described as "titanic" labours. We
also know that the room was very badly illuminated and that he had to rework
the tonality of his entire composition.

 All that remains today are some sketches and a certain number of preparat-
ory drawings. The ceiling was to have been occupied by a huge allegory, *Peace
Descends to Earth*, of which nothing has survived but a sketch (p. 76). In his
Journal, Delacroix describes the depicted scene thus: "The subject of the main
ceiling is the weeping Earth, raising her eyes to heaven to seek an end to her
misfortunes. Cybele, august mother, sometimes has very wicked sons who stain
her robe with blood and cover it in smoking ruins… Above, in an azure sky
gilded with light, whence the clouds are fleeing – last vestiges of the storm
swept away by a powerful breath – appears the figure of Peace, serene and radi-
ant, bringing with her abundance and the sacred chorus of the Muses, who
shortly before were fleeing…"

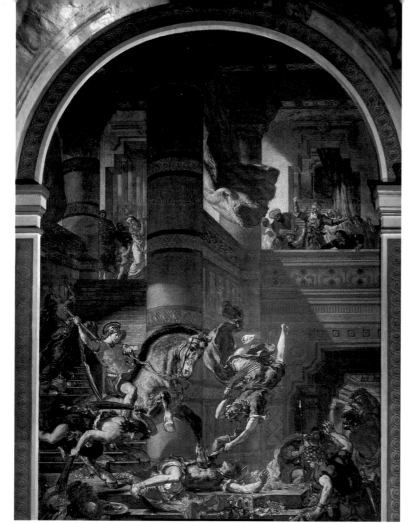

Heliodorus Driven from the Temple,
1854–1861
Oil and wax on plaster, 7.51 x 4.85 m
Paris, Saint-Sulpice

The great decorative works testify to the new inspiration and broader horizons that Delacroix had discovered on his Moroccan voyage. He had also learnt to draw upon classical mythology, Greek and Roman history and the Bible as never before. Though tired and ill, he adapted certain of his subjects from fresco to apply them to canvas, continuing to send works to the Salon. *Ovid among the Scythians* (pp. 82/83), a further treatment of the theme of civilisation confronted with barbarity, was submitted to the 1859 Salon. This was not a one way traffic; Delacroix also adapted material from his painting to his decorative compositions. There is a clear link between the Palais Bourbon *Attila* and *The Massacre of Chios*, *The Death of Sardanapalus* and *The Entry of the Crusaders into Constantinople*.

As the acknowledged master of monumental civic decoration, Delacroix could afford to stand aside from one of the major enterprises of his time, the decoration of religious monuments. But the Saints-Anges chapel at the church of Saint-Sulpice provided the opportunity for a kind of last testament. By a decree dated 28 April, 1849, Delacroix was commissioned to decorate a chapel at Saint-Sulpice. However, the urgent demands made by his numerous civic commissions and the doubtful state of his health hindered him fulfilling the decree. Only

Heliodorus Driven from the Temple (sketch),
1850
Oil on paper mounted on canvas,
56.2 x 38.5 cm
Fribourg, Musée d'Art et d'Histoire

PAGE 80:
Heliodorus (detail of the avenging angel)

PAGES 82/83:
Ovid among the Scythians, 1859
Oil on canvas, 88 x 130 cm
London, National Gallery

twelve years later, in 1861, did he complete the chapel. Given that it was con-
secrated to the Holy Angels, Delacroix chose to represent *Saint Michael De-
feats the Devil* on the ceiling, and *Jacob Wrestling with the Angel* (p. 79) and
Heliodorus Driven from the Temple (pp. 80/81) on the walls. Now badly wea-
kened by illness, he relied heavily on the help of his faithful assistants, Pierre
Andrieu and Louis Boulangé.

This time there was no critical consensus. There was praise for the delicate
gradation of tones in the *Heliodorus*, which was compared to Veronese and
Raphael, while Michelangelo was cited in relation to the muscular brutality of
Jacob. But contemporary critics were blind to Delacroix's originality in replac-
ing the traditional architectural background with a natural landscape. His very
rich and various palette, the harmony of the colours, and, in particular, the
subtlety of the greens in the foliage, prefigure the work of Corot. Delacroix here
shows himself the father of Impressionism. *Jacob Wrestling with the Angel* has
been read as a summary of Delacroix's life and work. Indeed the leitmotif of his
career is the struggle – a spiritual combat – between his aspiration to classicism
and his Romantic genius, between his admiration for Racine and his love of
Shakespeare. Maurice Barrès aptly perceived in the *Jacob* "a superlative piece
of autobiography, a summation of the experience of a long life, a testament of
death inscribed by the aged artist upon the wall of the Angels. It is full of church
music and the luminous harmony into which a true man brings the elements of
his life before the light fades".

Delacroix left another testament: the flower paintings and landscapes of his
later years. The symbolic import typical of Delacroix's subjects seems here to
be lacking. Timothy Clark sees in them "a deliberate and grand withdrawal to
a world of private sensation, a world of traditional painterly problems" [*The
Absolute Bourgeois*, p. 131]. They might be described as an early case of 'art for

art's sake'. Like Renoir painting roses with the colours left over from a session with a nude, Delacroix took time off from his exhausting monumental labours to paint the flowers in the garden of his friend George Sand. In her words, "I surprised him ecstatic with delight before a yellow lily whose beautiful *architecture* (his very apt choice of word) he had just apprehended". With his friend Joséphine de Forget, he is said to have "prowled around rose bushes". Charles Baudelaire once again finds the proper metaphor, speaking of "volcanic craters artistically concealed behind bouquets of flowers". The critic L. Cailleux more innocently notes that "Delacroix stumbled on the secret of flowers and their airy ease of manner, which he then set forth with characteristically impulsive energy".

Can it have been the fervid master of Romanticism who noted in his *Journal* of 1850: "This evening, ravishing moonlight in my little garden. Stayed up walking very late. Could not get enough of the gentle light on the willows, the sound of the little fountain and the delicious odour of the plants, which seemed, at that hour, to surrender all their hidden treasures?" It might almost be Monet strolling through his garden at Giverny.

As an exponent of the "purest classicism" who sought to emulate the great masters, Delacroix owed it to himself to be able to paint flowers and landscape, even if the themes that he generally espoused were more ambitious. The *Journal*

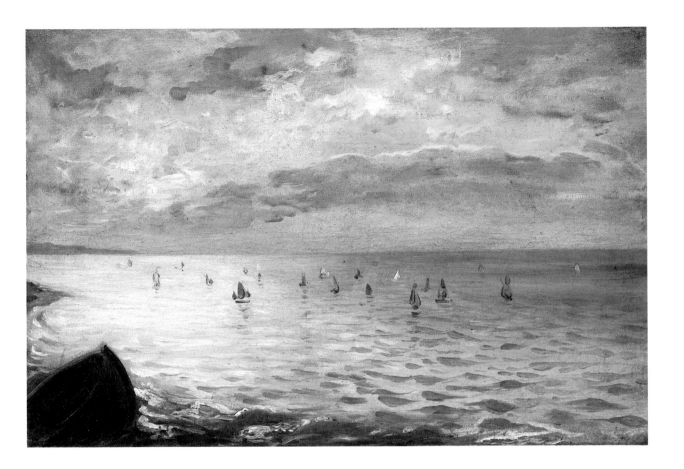

nevertheless informs us that the golden sky above the chariot of Apollo in the Louvre derived from a series of landscapes. Like the Impressionists, like a musician practising his scales, Delacroix painted at his leisure the endlessly varying spectacle of daylight; skyscapes (p. 86), setting suns, and the nocturnal scenes inspired by the forest of Sénart and the countryside around Champrosay. But it is *The Sea from the Heights of Dieppe* (above), formerly hung in the Musée Delacroix in Paris, that placed alongside Monet's celebrated *Impression. Soleil levant* most clearly demonstrates Delacroix's importance for the Impressionists. Whether or not it was painted in situ, the rapidity of the brush strokes prefigures the rapid notations of the open-air school.

Throughout his life, Cézanne dreamed of painting an *Apotheosis of Delacroix*. The dream was never realised, and only a sketch has survived (p. 95). Here we see Delacroix raised into the sky by angels, one of whom holds his brush, the other his palette. Below them stretches a landscape in which Pissarro stands before his easel, painting in the open air. To the right is Claude Monet, and in the foreground Cézanne, surmounted by an enormous Barbizon hat. To the left is Victor Choquet, who collected first Delacroix and then the Impressionists. They applaud the ascent into the next life of that most worldly painter, Delacroix; the man who once said: "Give me the mud from the streets and I shall make of it the delicious tones of a woman's flesh."

The Sea from the Heights of Dieppe, 1852
Oil on cardboard mounted on wood,
35 x 51 cm
Paris, Musée du Louvre

PAGES 88/89:
A Basket of Flowers overturned in a Park,
1848–49
Oil on canvas, 107.3 x 142 cm
New York, The Metropolitan Museum of Art

Even Delacroix's flowers have a monumental air: "I attempted to do fragments of nature as they appear in gardens, merely bringing into the same painting, in fairly probable fashion, the greatest variety of flowers."

Delacroix

Life and Works

Self-Portrait with Cap, 1832
Drawing, 19.3 x 12.7 cm
Paris, Musée du Louvre, Département
des Arts graphiques

PAGE 91:
Léon Riesener
Delacroix, 1842
Daguerreotype
Paris, Musée d'Orsay

1798–1814

On 26 April, 1798, Eugène Delacroix was born at Charenton-Saint Maurice, the fourth child of Victoire Œben, daughter of the famous cabinet-maker. Her husband was Charles Delacroix, Foreign Minister under the Directory. However, there is some reason to believe that Delacroix's real father was the famous diplomat Talleyrand (1754–1838), whom Delacroix was said to resemble in character and appearance. Charles Delacroix was appointed Prefect of the Gironde, and died in 1805. On his death, Mme Delacroix returned to Paris to live with her daughter, Henriette de Verninac. Eugène became a boarder at the then Lycée Impérial, today's Louis-le-Grand. In 1814, his mother died, leaving him an orphan at the age of sixteen. In the same year, Napoleon I abdicated on 6 April and Louis XVIII was crowned king.

1815–1818

Eugène lived with his sister Henriette. In 1815, he completed his secondary education. On the advice of his uncle, the painter Henri-François Riesener (1767–1828), he entered the studio of the Neo-classical painter Pierre-Narcisse Guérin (1774–1833), and copied Raphael and Rubens in the Louvre. The following year was spent at the Ecole des Beaux-Arts, where he made friends with Bonington and Pierret. Eugène and his nephew Charles de Verninac basked in the warm atmosphere of the Riesener family home, but it was at his sister's house that Eugène met his first love, the young English woman Elisabeth Salter. His portrait of her is dated 1817.

1819–1822

Delacroix received his first commission, a *Virgin of the Harvest* for the church at Orcemont; the influence of Raphael is evident. But his own tastes were closer to those of Géricault, whose *Raft of the Medusa* he admired. Géricault obtained for him a commission: the *Virgin of the Sacred Heart* for Ajaccio Cathedral. The premature death of Géricault in 1824 devastated Delacroix. Disastrous investments made his financial situation increasingly precarious, and he was forced to earn money by drawing caricatures. Thanks to the support of Antoine-Jean Gros, one of his works was accepted for the 1822 Salon, and subsequently acquired by the state: *The Barque of Dante*. Delécluze described the painting as a "daub", but the young journalist Adolphe Thiers spoke of "genius" and saw promise of "immense works", a promise that Thiers helped to fulfil when given a ministry after the 1830 Revolution. The first symptoms of the tubercular laryngitis of which Delacroix was to die now appeared.

1823–1824

Delacroix lived for a while at the home of the English watercolourist Thales Fielding, who introduced to him the English landscape school, and particularly John Constable, whose influence is clear in the *Still Life with Lobsters*. In the 1824 Salon, Delacroix presented *The Massacre of Chios*, a personal reaction against the genocide practised by the Sublime Porte against the Greeks. It had required numerous preparatory studies. This work placed Delacroix firmly among the Romantic painters, against whom were ranged the Classical painters led by Jean Auguste Dominique Ingres. Delacroix's aspirations were fanned by the exalted Romanticism of the poets that he most admired: Victor Hugo and Lord Byron.

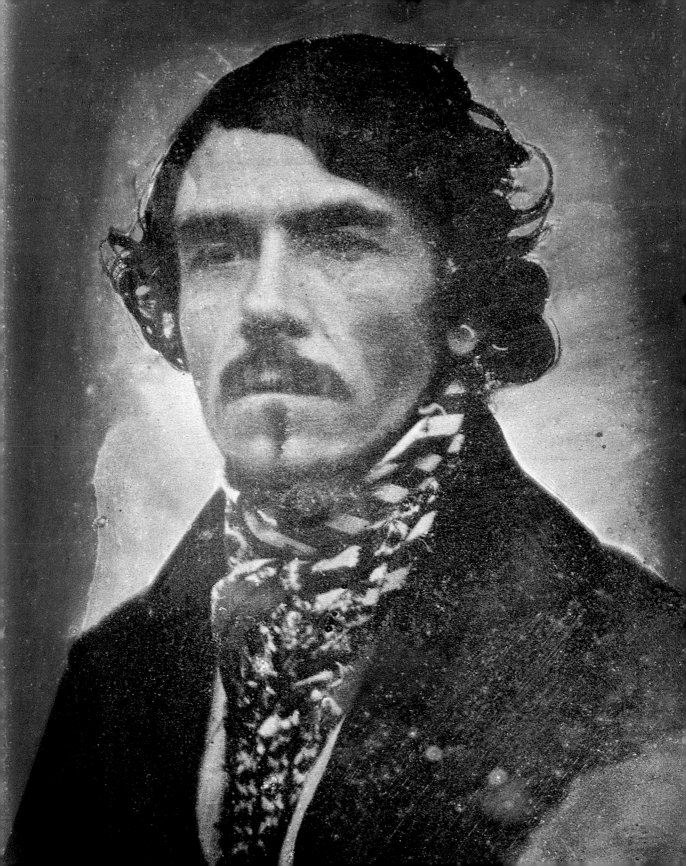

Talleyrand (1754–1838)

Delacroix, c. 1860

1825–1826

Through Bonington, Delacroix met a former dancer at the Opéra, Mme Dalton, who became his mistress. Delacroix spent the summer months in England, acquainting himself with English literature; this bore fruit in his lithograph illustrations to *Macbeth* and *Hamlet.* He also drew the heroes of Sir Walter Scott and Byron. Some years later, Goethe's *Faust* was to inspire a series of seventeen lithographs, which were published in 1828.

1827–1831

Delacroix's sister, Henriette de Verninac died. Bonington followed in 1828. At the 1828 Salon, Delacroix exhibited the *The Death of Sardanapalus*, a highly controversial work, and *The Execution of Marino Faliero.* In 1829, he settled at 15 quai Voltaire. He worked hard: studies for the *Battle of Nancy* and *Battle of Poitiers* and many portraits. The July Revolution of 1830 brought the abdication of Charles X and the coronation of Louis-Philippe. In his *Liberty Leading the People*, Delacroix painted a reflection of the political struggles around him. The controversy around Hugo's play, *Hernani*, ended with the triumph of Romanticism. Delacroix, meanwhile, continued to frequent the highest society. He numbered Stendhal, Merimée and Alexandre Dumas among his friends. In the *Revue de Paris*, he published articles on Michelangelo and Raphael. Each summer, he would stay with his cousins at Valmont.

In 1831, he was awarded the Légion d'honneur.

1832

This year brought a major event. On the recommendation of Mlle Mars, he made the acquaintance of Comte Charles de Mornay, Ambassador to the Sultan of Morocco, Abd er-Rahman. Delacroix was appointed to accompany the Count on a voyage which began with a stay in Tangier, then Meknès, Cadiz, Seville, Oran and Algiers; he arrived back in France on 5 July. These six months filled Delacroix's notebooks with drawings, sketches and watercolours. The life and customs of the Arabs fascinated him and were to inspire many paintings. Manet was born in 1832.

Elisabeth Salter, 1817

Madame Pierret, 1827

Study for Jenny Le Guillou
(above) *and Joséphine de*
Forget (right)
Drawing, 32 x 20.8 cm
Rotterdam, Museum Boijmans
Van Beuningen

George Sand and Auguste Charpentier, Fan
with Caricatures, 1838
Centre: Liszt, Delacroix, Sand and Chopin as
birds of paradise
Paris, Musée Renan Scheffer (Musée de la Vie
romantique)

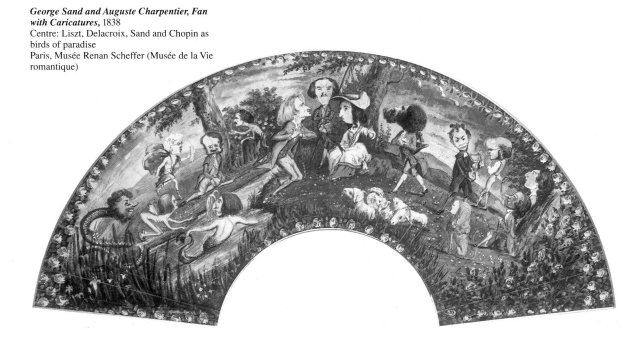

Henri Fantin-Latour
Homage to Delacroix, 1864
Oil on canvas, 160 x 250 cm
Paris, Musée d'Orsay

This painting was exhibited at the Salon
des Refusés in 1864, a year after Manet's
Le Déjeuner sur l'herbe, and caused a con-
siderable stir. One reason for this was the
juxtaposition around Delacroix of per-
sons of widely varying ideologies: Romantic
critics like Baudelaire, Realist critics like
Champfleuri and Duranty, and contemporary
artists of divergent styles and sympathies,
such as Whistler, Manet and Fantin-Latour
himself. *Homage to Delacroix* thus took the
form of a veritable manifesto for the up-and-
coming generation in all its diversity, all of
whom acknowledged in Delacroix – the Ro-
mantic master and exponent of 'pure Classi-
cism' – the freedom that they claimed for
themselves.

1833–1837

Thiers commissioned Delacroix to
decorate the King's Chamber in the
Palais Bourbon. Despite Salon refusals
and the rejection of his candidacy for
the Institut de France, Delacroix re-
ceived many commissions and orders
for portraits. He greatly mourned the
death of his nephew Charles de Ver-
ninac, but enjoyed a ready welcome in
the household of the Pierret family
and of Villot, whose wife Pauline be-
came his mistress and modelled for
him in the Villot property at Cham-
prosay. At this time, too, began his
amitié amoureuse with George Sand,
though his most tender feelings were
reserved for his cousin, Joséphine de
Forget, his mistress for many years.
His *Women of Algiers in their Apart-
ment* was a great success at the 1834
Salon.

1838–1844

Important commissions flowed in. He
decorated the library of the Chambre
des députés, in 1840 that of Chambre
des pairs in the Palais du Luxembourg,
then the Chapel of the Holy Sacra-
ment at Saint-Denis. To execute these
enormous works he required the help
of assistants from his studio, the most
faithful of whom was Pierre Andrieu.
He nonetheless continued to exhibit at
the Salons: the *Jewish Wedding in Mo-
rocco, The Shipwreck of Don Juan,
Medea about to Kill Her Children,* and
*The Entry of the Crusaders into Con-
stantinople.* And he still travelled: in
1839, he went with Elisa Boulanger to
Holland; he often stayed at Valmont;
in 1842, he visited Nohant, being very
close to both Sand and Chopin. In
1839, Cézanne was born; in 1840
Rodin, Monet and Zola.

1845–1849

To alleviate his throat condition, Delacroix spent a season in the Pyrenees. He brought back drawings and watercolours of the mountain landscape. His brother Charles died in 1845. Eugène stayed briefly in Bordeaux to execute the will. The accession of Louis-Napoleon in 1848 brought the prospect of further state commissions, but his candidacy for the Institut was repeatedly rejected. In 1849, he was commissioned to paint a chapel in Saint Sulpice, though the work was postponed for several years. Jenny Le Guillou, who had been his mistress for some time, remained at the centre of his life until the end. Delacroix met Corot and wrote an article on Gros.

1850–1856

Commissioned to decorate the ceiling of the Apollo Gallery in the Louvre, which he completed in 1851. Before undertaking the work, he travelled to Belgium to draw inspiration from Rubens. He also decorated the Salon de la Paix in the Paris Hôtel de Ville (this work was destroyed during the Commune). Delacroix spent most summers at Champrosay and at Dieppe; the sea vistas he painted at Dieppe, along with his flower-paintings, had a great influence on Impressionism. In 1855, he exhibited forty-eight paintings at the Universal Exposition in Paris. On his eighth attempt, he was made a member of the Institut. The previous year, he had been named Commandeur of the Légion d'honneur.

1857–1863

In 1857, Delacroix left the quai Voltaire for 6 place de Furstenberg, where he had a huge studio constantly maintained at high temperatures owing to his throat condition. In 1857, France completed the conquest of Algeria. There were literary scandals; Flaubert was sued for *Mme Bovary* and Baudelaire for *Les Fleurs du Mal*. 1859 was the last Salon in which Delacroix participated; despite his assiduity, he could no longer work continuously, and was forced to take rest cures in the country. In 1861, he completed the Saint-Sulpice frescoes and began the decoration of the dining room of the banker Hartmann. In 1863, his condition worsened; he contrived to paint *The Moroccan Chieftain Receiving Tribute* and *Toby and the Angel*, but on 13 August he died, alone apart from the loyal Jenny Le Guillou. In that year, a Salon des Refusés was opened for the artists rejected by the official Salon. Manet raised uproar with his *Déjeuner sur l'herbe*, while Cabanel was acclaimed for his *Birth of Venus*.

1864

The artist's studio was sold at the hôtel Drouot. Fantin-Latour presented his *Homage to Delacroix*. Even after the death of Delacroix, 'the prince of Romantics', Fantin-Latour's homage was considered scandalous.

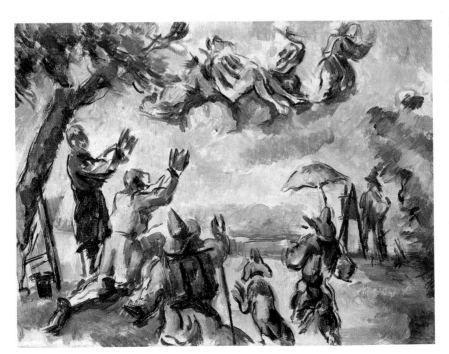

Paul Cézanne
Apotheosis of Delacroix,
c. 1894
Oil on canvas,
27 x 35 cm
Aix-en-Provence,
Musée Granet

In 1904, Cézanne wrote to Emile Bernard: "I don't know whether my faltering health will allow me to realise my dream of an *Apotheosis of Delacroix*." All that remains of the project is this sketch.

Photo credits

The publisher and author would like to
thank the museums, archives and photo-
graphers who have given permission for the
reproduction of the illustrations and kindly
assisted in the creation of this book.

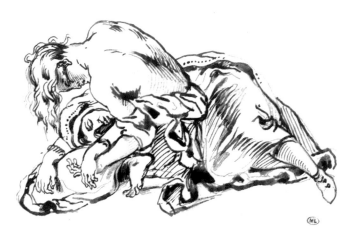

Young Woman Leaning over a Woman Stretched out on the Ground, study for the two women
prisoners in *The Entry of the Crusaders into Constantinople*
Pen and wash, 10.5 x 17.5 cm
Paris, Musée du Louvre, Département des Arts graphiques

Abbreviations: a = above, b = below,
r = right, l = left.

In addition to the institutions cited in the
captions, we should also like to thank:

© Artephot/Held, Paris: 65

© Artephot/Takase: 78

Michel Bodycomb '98: 2

© Bridgeman-Artothek: 84 r

© Bridgeman-Giraudon: 62

Cliché Frédéric Jaulmes: 9, 13 l

© Cliché du M.B.A. de Bordeaux, Lysiane
Gauthier: 6

Cliché Bernard Terlay: 95

© Fitzwilliam Museum, University of
Cambridge: 18 b

© Giraudon, Paris: 50, 54 l, 54 r

© Lauros-Giraudon: 79, 80, 81 l

© 1980 The Metropolitan Museum of Art,
New York: 88/89

Musée des Beaux-Arts de Lyon, Studio
Basset, Caluire: 19

© Nasjonalgalleriet, J. Lathion: 48

Öffentliche Kunstsammlung Basel, Basle,
Martin Bühler: 17, 21 b r

© Photo Bulloz: 51 a

© Photo Josse: 70, 71 a, 71 b, 72 a, 72 b, 73 b,
75

© Photo RMN, Paris, Arnaudet: 7, 11 a l, 21 l

© Photo RMN, Paris, Arnaudet/G.B.: 40

© Photo RMN, Paris, Arnaudet/J. Scho.: 45

© Photo RMN, Paris, Michèle Bellot: 7,
14 a r, 29 a, 51 b l, 55, 86, 90

© Photo RMN, Paris, J.G. Berizzi: 8,
38 a r, 39, 56, 68, 73 a

© Photo RMN, Paris, Gérard Blot: 1, 12,
14 a l, 24, 43, 52

© Photo RMN, Paris, Gérard Blot/C. Jean:
66, 69

© Photo RMN, Paris, C. Jean: 16

© Photo RMN, Paris, Hervé Lewandowski:
cover, 15, 18 a, 20, 21 a r, 23, 25, 27, 28, 29 b,
31, 32, 64 a, 87, 94

© Photo RMN, Paris, R. G. Ojeda: 34, 35, 37,
38 b, 41 a, 91

© Photo RMN, Paris, Jean Schormans: 22, 36

© Photo RMN, Paris: 10, 11 b r, 13 r, 26, 53
a, 63, 67 a, 67 b, 74 a, 84 l, 96

© Photothèque des Musées de la Ville de
Paris, Ph. Ladet: 93 b

© Photothèque des Musées de la Ville de
Paris, P. Pierrain: 76

The Pierpont Morgan Library, New York.
1985.33, Bequest John S. Thaicher.
Photography: Schecter Lee: 46 b

© 1994 Skm, Hans Thorwid: 60/61

© Ole Woldbye: 38 a l